ZEN Girls

Drawing Amazing ZEN Doodle Girls

By Jane McKenty

Copyright©2015 Jane McKenty
All Rights Reserved

Copyright © 2015 by Jane McKenty

All rights reserved. No part of this publication may be reproduced, distributed, or transmitted in any form or by any means, including photocopying, recording, or other electronic or mechanical methods, without the prior written permission of the author, except in the case of brief quotations embodied in critical reviews and certain other noncommercial uses permitted by copyright law.

Table of Contents

Introduction — 5

Lesson One: Prancing young lady — 7

Lesson Two: The fairy — 34

Lesson Three: Missing miss amidst the mist — 48

Lesson Four: A nightly butterfly — 75

Lesson Five: Her hat suits her well — 94

Conclusion — 105

Other Books from Jane McKenty — 107

Disclaimer

While all attempts have been made to verify the information provided in this book, the author does assume any responsibility for errors, omissions, or contrary interpretations of the subject matter contained within. The information provided in this book is for educational and entertainment purposes only. The reader is responsible for his or her own actions and the author does not accept any responsibilities for any liabilities or damages, real or perceived, resulting from the use of this information.

The trademarks that are used are without any consent, and the publication of the trademark is without permission or backing by the trademark owner. All trademarks and brands within this book are for clarifying purposes only and are the owned by the owners themselves, not affiliated with this document.

Introduction

Before we begin

Welcome to *"ZEN Girls: Drawing Amazing ZEN Doodle Girls!"*, dear reader, here will teach you how to do ZEN Doodling. The following five lessons will present examples that will be explained how they should be made, in an easy to understand step by step method. Perhaps you are apprehensive about taking this journey if you do not have an instinctive ability for drawing, but let us ensure you that being gifted or not does not make a difference here. ZEN Doodling is not about firm techniques, but about learning to exploit your creative side.

On the other hand, those who have already a good grasp on sketching, drawing, and are naturally brilliant in the Arts will find endless hour of entertainment in this how-to- book. It will probably be noted by the avid reader that the exercises presented show as examples not typical ZEN Doodling, the ones portrayed here have a clear inspiration on those vintage 1920 advertisement posters in their design. This can be seen with the clear one line shape of the drawings, which mashes really well with the simplistic, yet apparently complicated pattern of the ZEN Doodling.

Talking about the pattern of this art technique let us give you the first instructions: put your markers on the table and your eraser out of it; the position of the page does not matter, you have the liberty to change it whenever or however you want; please, do say your goodbye to the straight lines, and say hello to the curves- this, along with circles, and various oval shapes will guide your hands in this journey-. So just take a sheet of paper and sit down, you will feel like if you were back in class or if you are in class you will be making something more elaborated than those doodles that plague the corners of your notebook. Whichever it is, you will have fun learning here.

It is a firm idea here to make this as relaxing as can be, we will not be pressuring you to get all in the first attempt, we will take various paths, procedures, and practices so anyone can get a grasp of this. Also, making this complicated and strenuous would make it go against its own nature. Let us give you a crash course on ZEN Doodling. What is that? You may ask. Well, it is Japanese school of the Mahayana Buddhism that comes from the Chinese *Chan*, which asserted meditation and intuition above religious or theological matters. This is combined with curves and curls, giving twisted and chaotic look. So basically, you will be fiddling figurines finding figures.

Lesson One: Prancing young lady

This is what we want to achieve:

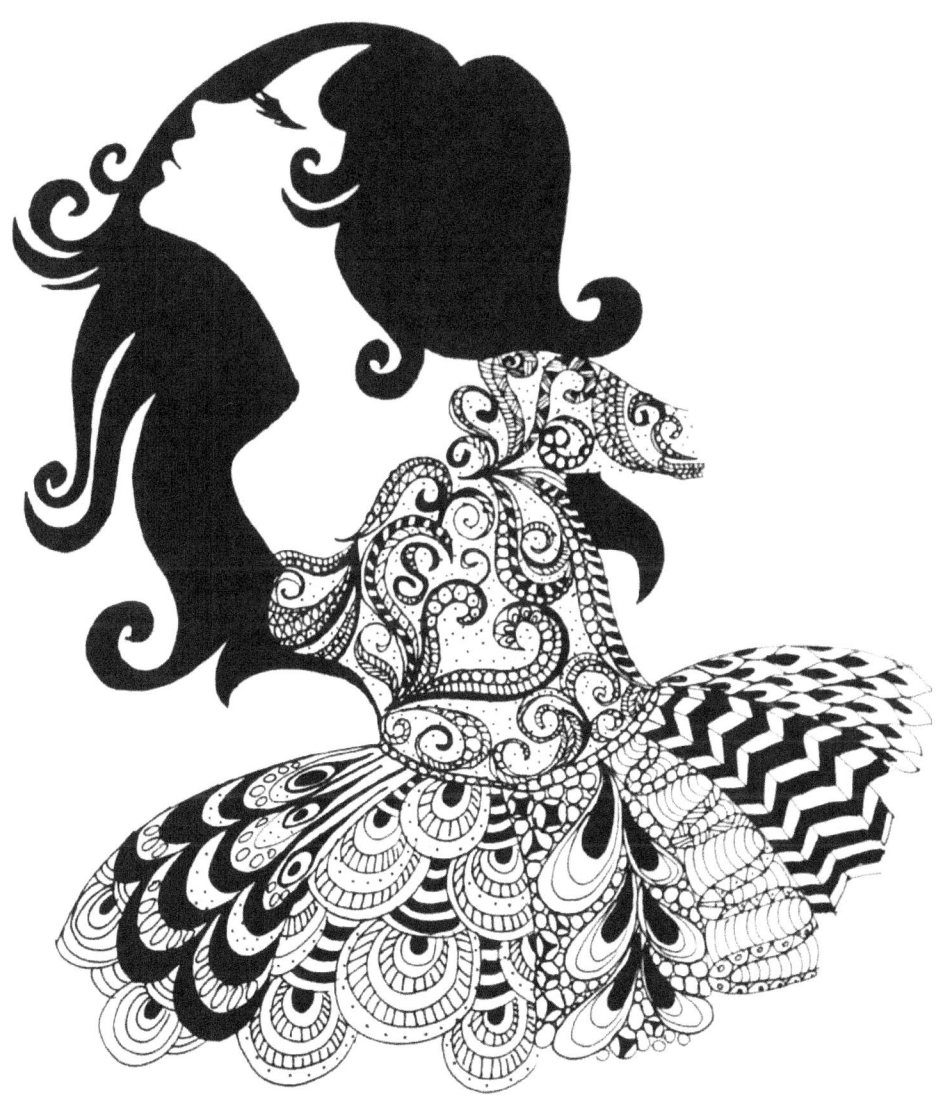

And this is how we are going to get there:

Step zero:

This goes for every activity in this book, so we will skipping this one in the following chapters, search for a sheet of paper (it is highly recommended to use a rough kind, so the ink won't trespass it, like a paper for watercolor or canvas-, but if you are careful you can use a normal paper used for printing), with the most suggested sizes being: Office, A4, or A3; pens (of that there are many options, such as: fountain, graphic, drafting, reed, and ballpoint ones.- It is recommended to use 00.5 for miniscule details, the 0.5 for internal lines, and the 1.00 and so on for contours-);

Concomitant of the pens are the markers, these tools can be used to *paint* the blank spaces- either an oil or water based marker can be equally up to the task at hand-.

Also, because we are just practicing here, we are going to let you cheat, so get your eraser back in the table and take your pencil (B or

HB can both work, in both traditional and mechanical types).

Probably by the end of this you will have no need of erasing more, but for the moment we will let you make some corrections while working on this.

Now that we have the materials and tools we can begin.

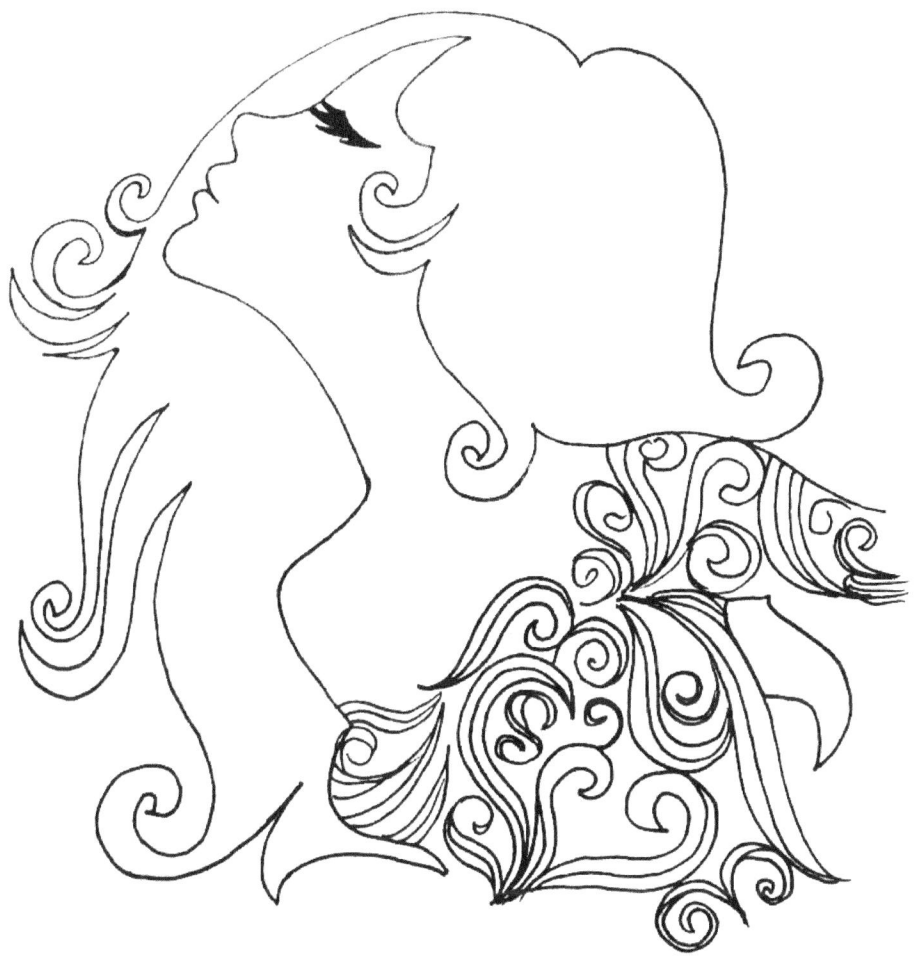

Step 1: We propose as a first phase to take good look at this picture, analyze it, see how much space it occupies, try to see what shapes make it. Once you are familiarized with the figure, we propose that you make one vertical curved on the higher end line, and in the middle nearing the bottom an almost S shaped horizontal line. Remember to do this with a gentle stroke of the pencil, this will be deleted later. The same goes for the next instruction- keep using the pencil for now-.

Step 2: After this we will deconstruct this drawing to its more basic nature. It is a firm belief of ours that everything can be simple if we make it so, therefore, we will make this easy for you. Use geometrical figures to trap the sketch inside of them, like this: use an oval for the face, two circles for the shoulders, another one for the side of the lady's bosom, and two rectangles for the neck and bust.

Within the boundaries of this figures you can start playing with the pencil try letting your lines flow using your entire arm from the shoulder to work, this will help to lose your streak, furthermore, it will serve to keep an eye on the entirety of the picture.

We will strive to achieve the profile and bust section in one swept curved line; with the same idea for the other side, and the conjunction of arm and shoulder.

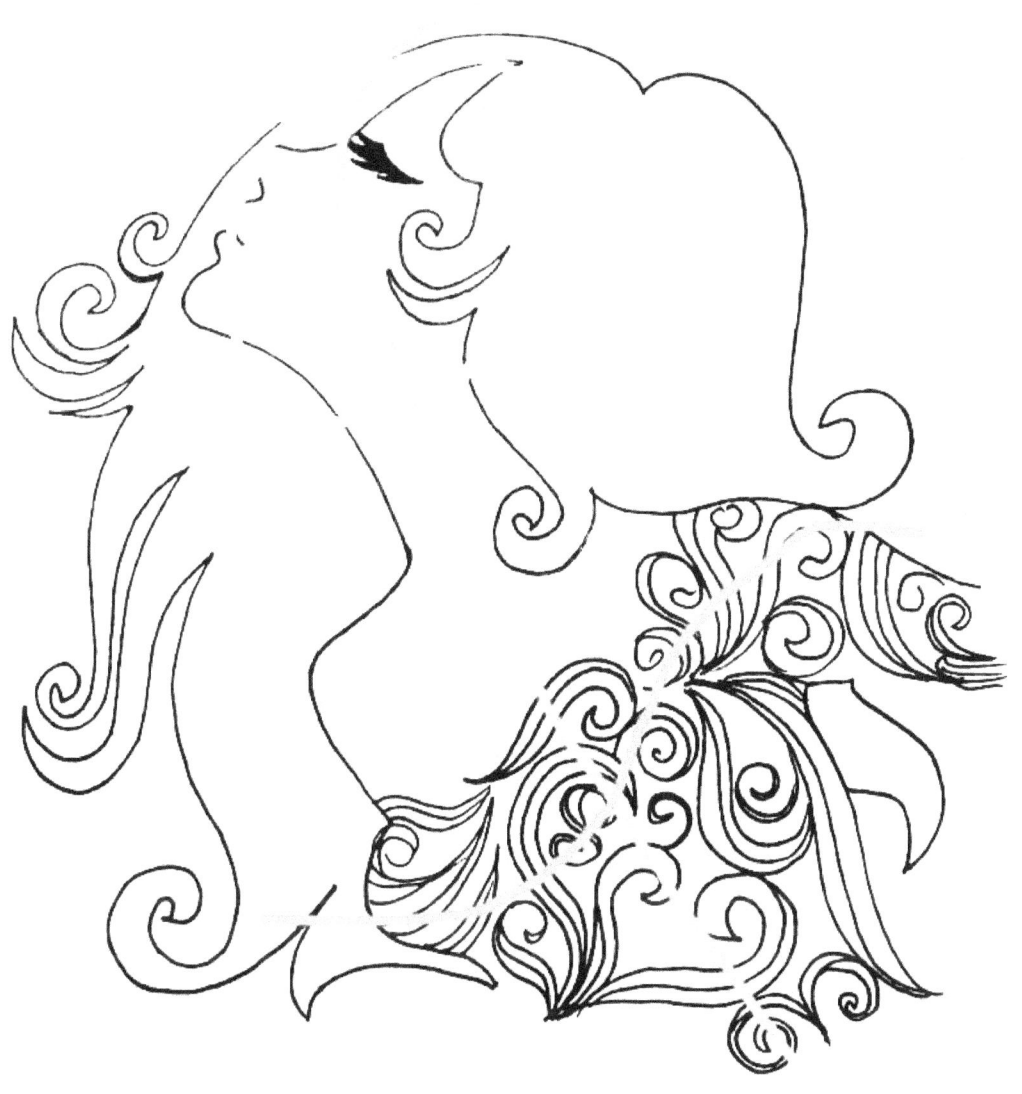

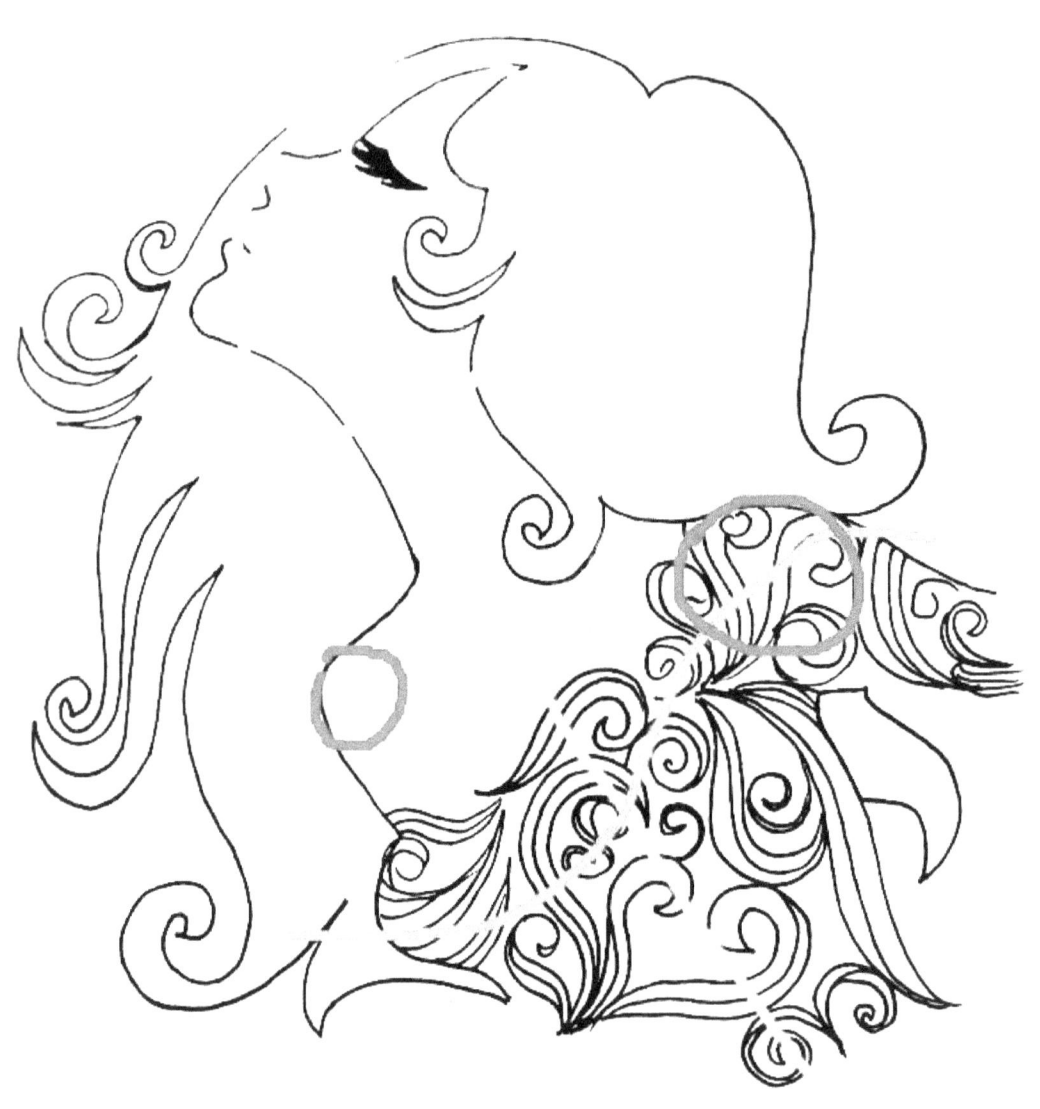

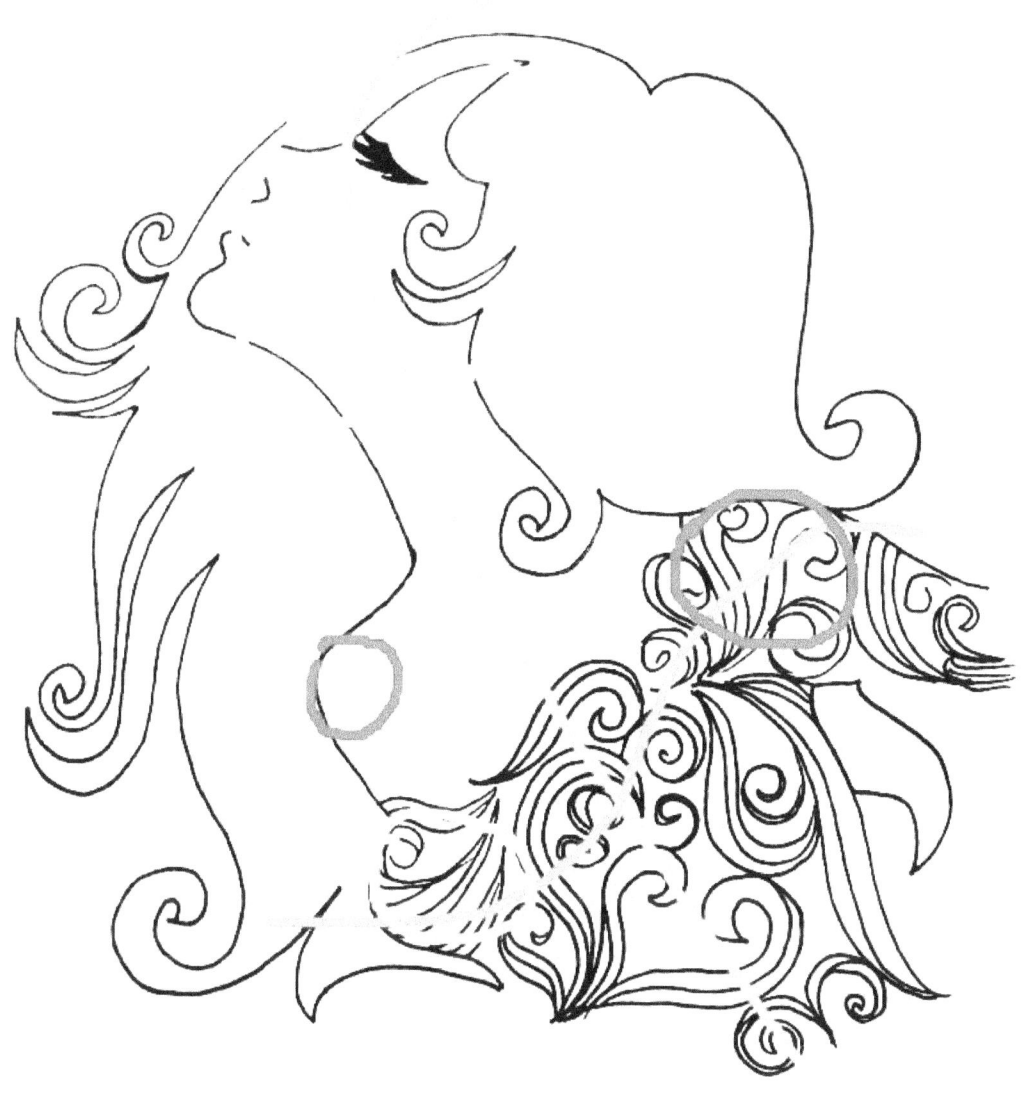

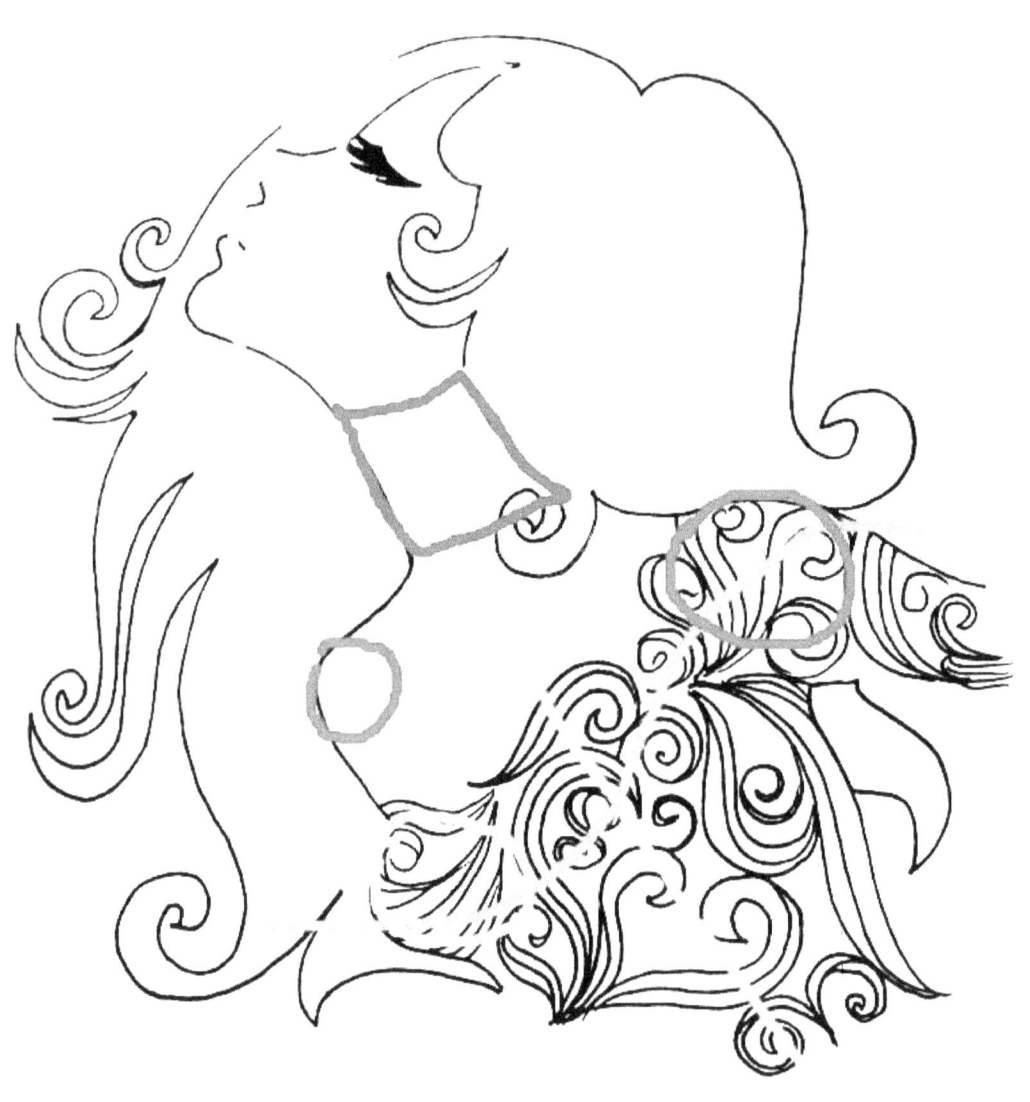

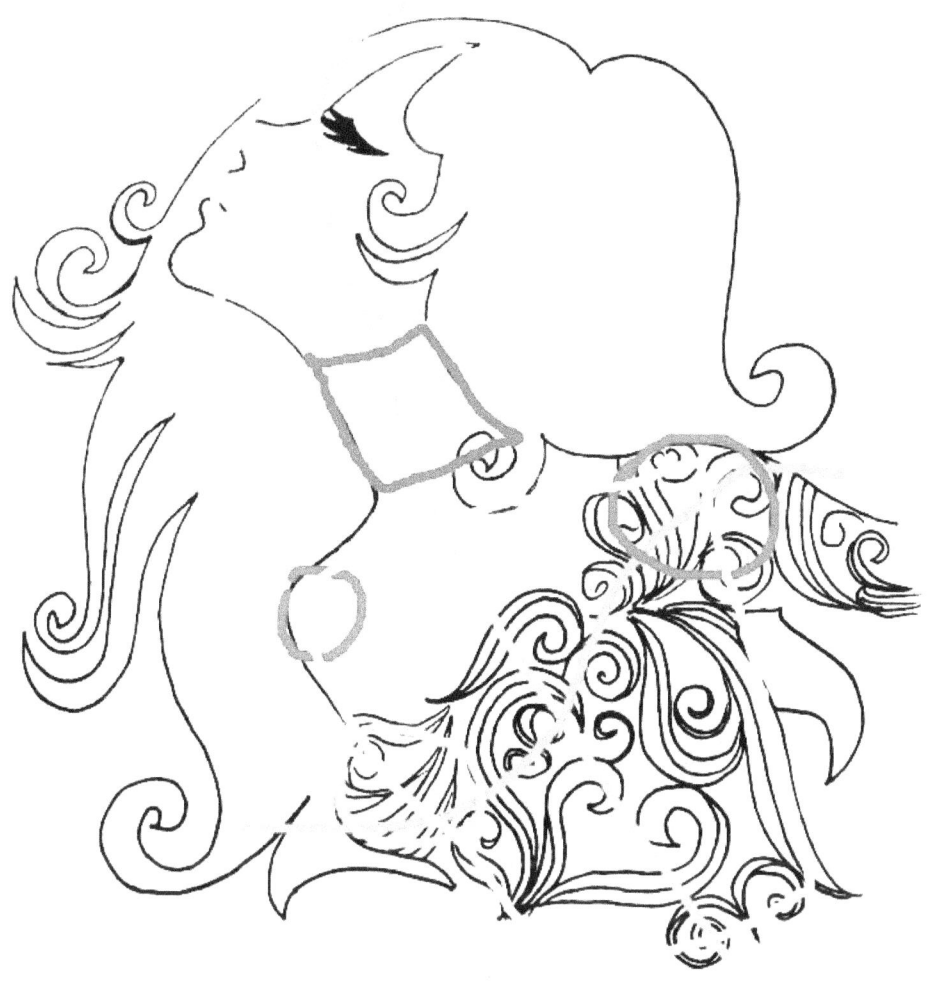

Step 3: Having this we can pass to the hair, notice how it is formed by various curls and curves, have them on mind while drawing, and try to make some of your own on the sheet. Follow the long lines as they are shown on her hair, and stop at the tips, so you can model them into curls, create one after the other, soon you will have a voluminous hair thanks to this loops.

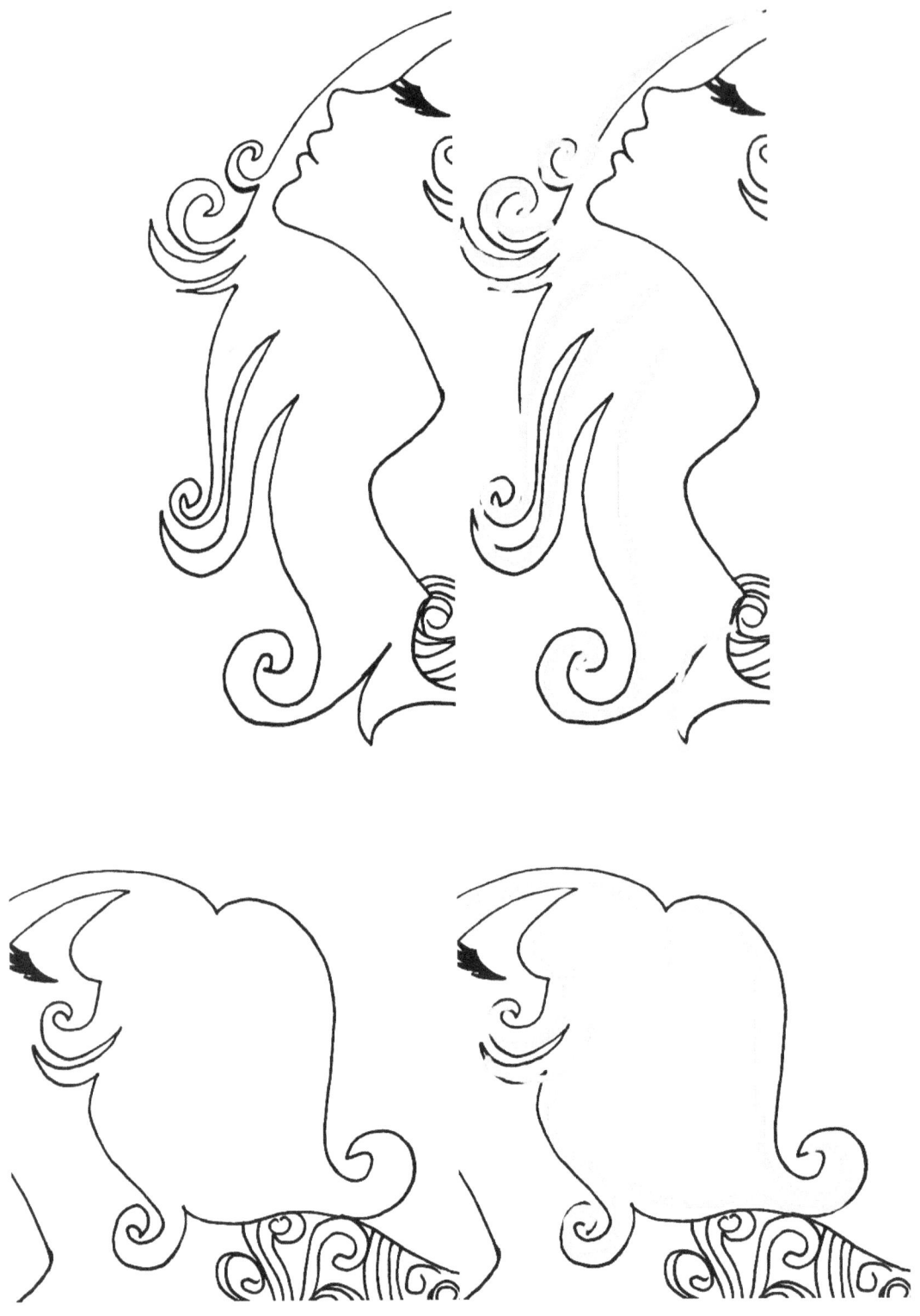

Step 4: So now that you have the figure, you won't need the guiding lines or geometrical shapes no more, so you will have to erase them. But before you do, it will be preferable if you ink with a thin pointed pen-any of the already mentioned can do the work-. Once this is done use the rubber so you can delete the unnecessary things on the paper.

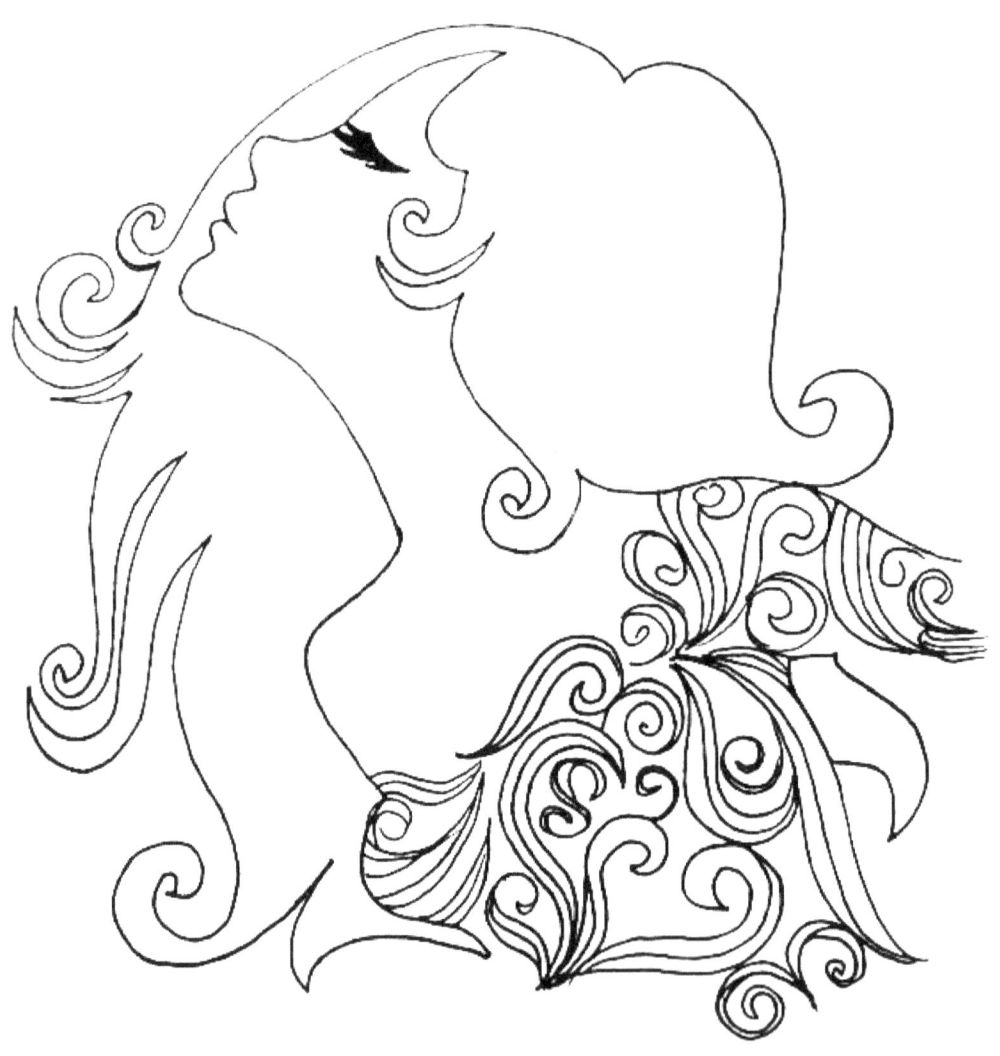

Step 5: Following this, we will help you create the clothes for this lady, from the bust downwards start doodling circles, curved lines, chords, and curls; do attempt for these silhouettes to model after the volume we want to achieve. Do the same with the arm and shoulders, but do leave the face and the space occupied from the neck to the shoulder free. The image above, it serves just as an example, but you can play filling the blank space as you wish.

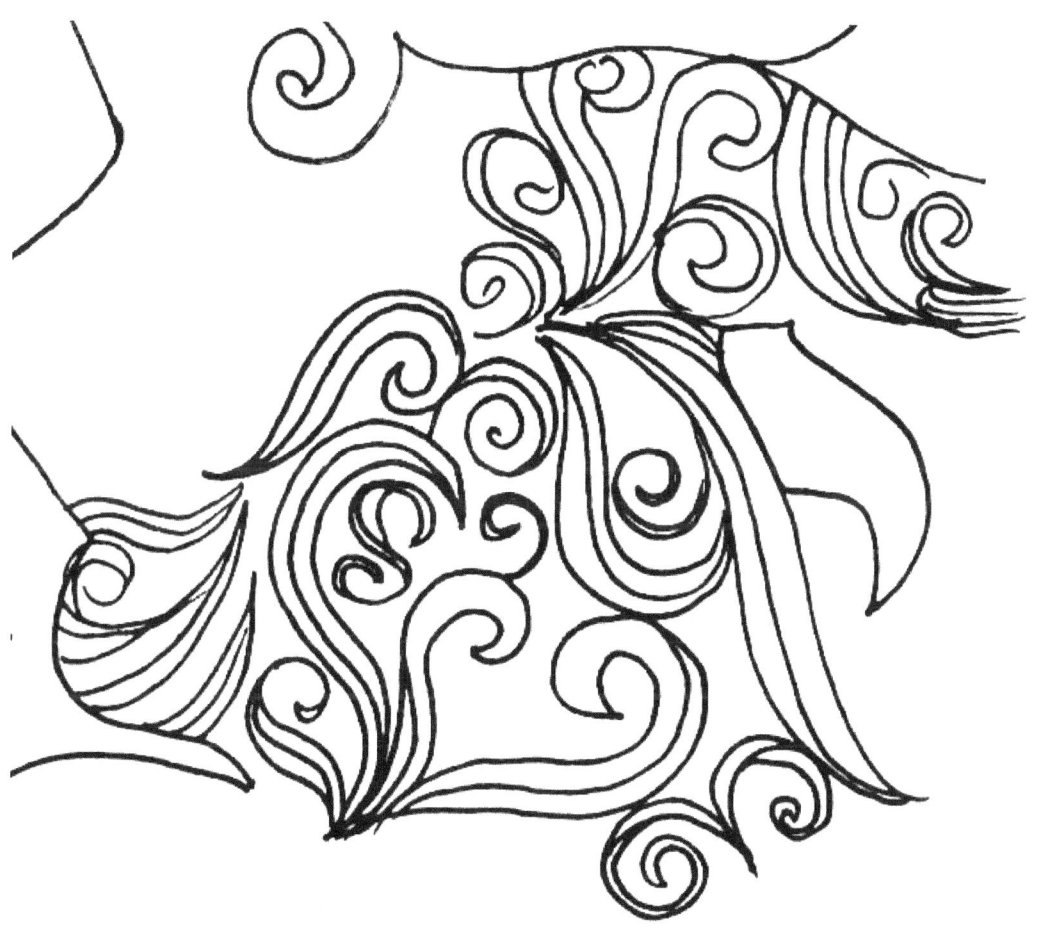

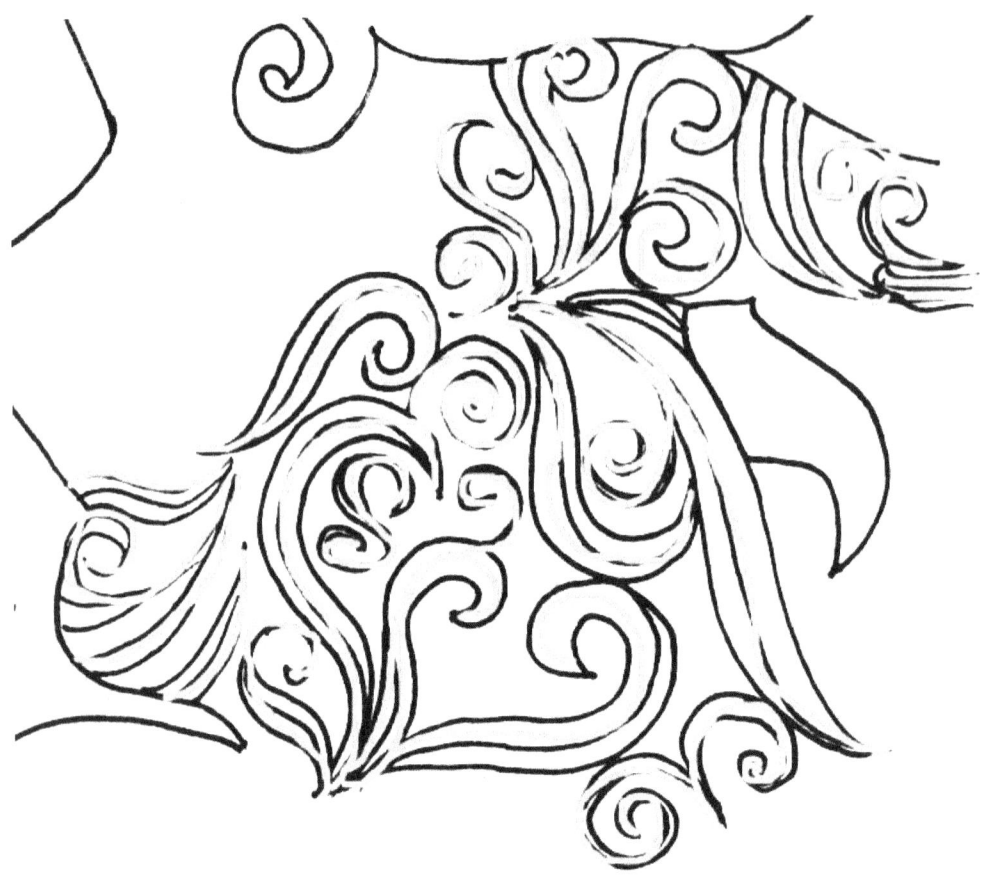

Step 6: We will keep our attention at the chest section of this image; see those curves you have already drawn, make a sister one to each of them, making them encounter at some point, you will creating the outlines of various wallies.

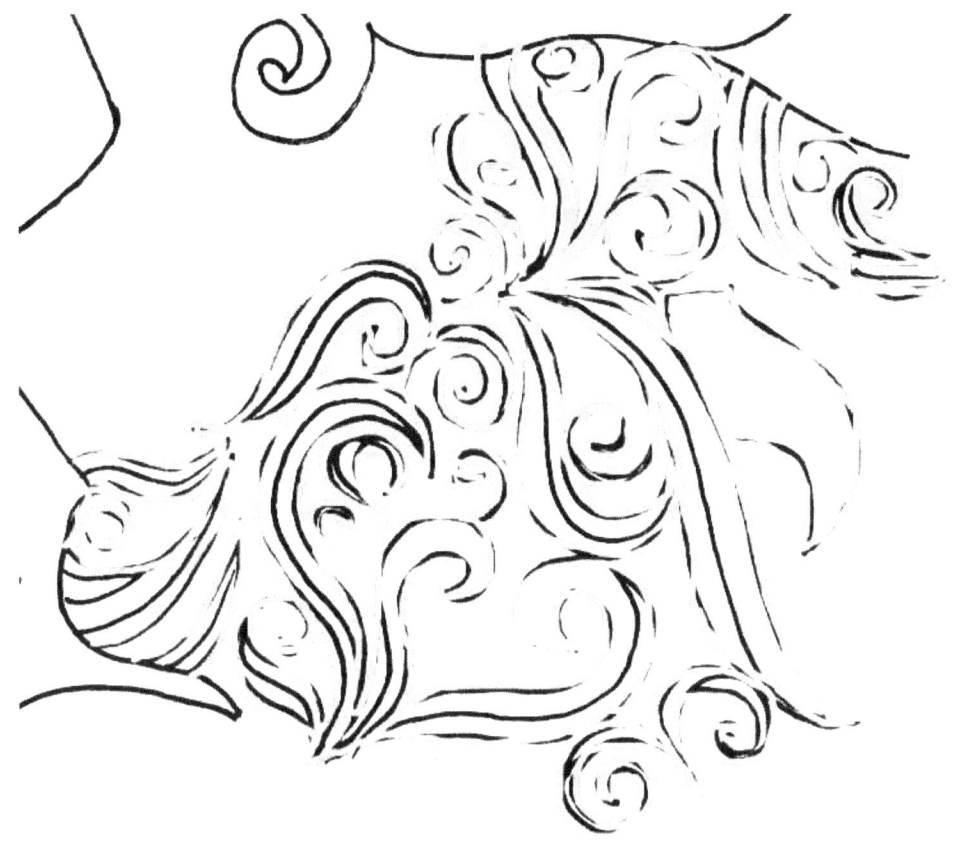

Step 7: Do start the inking process for the paper wallies, see if there is anything in the design you just made that you want to highlight; if that is the case you use the marker to ink the outlines. Maybe you have notice that there is a heart shaped form marked out in the drawing, for this it will be recommended to use a wider type of pen-a 1.0 one can suffice-. In this case the figure looks like a heart, but you can make it look however you want to. (See the picture below)

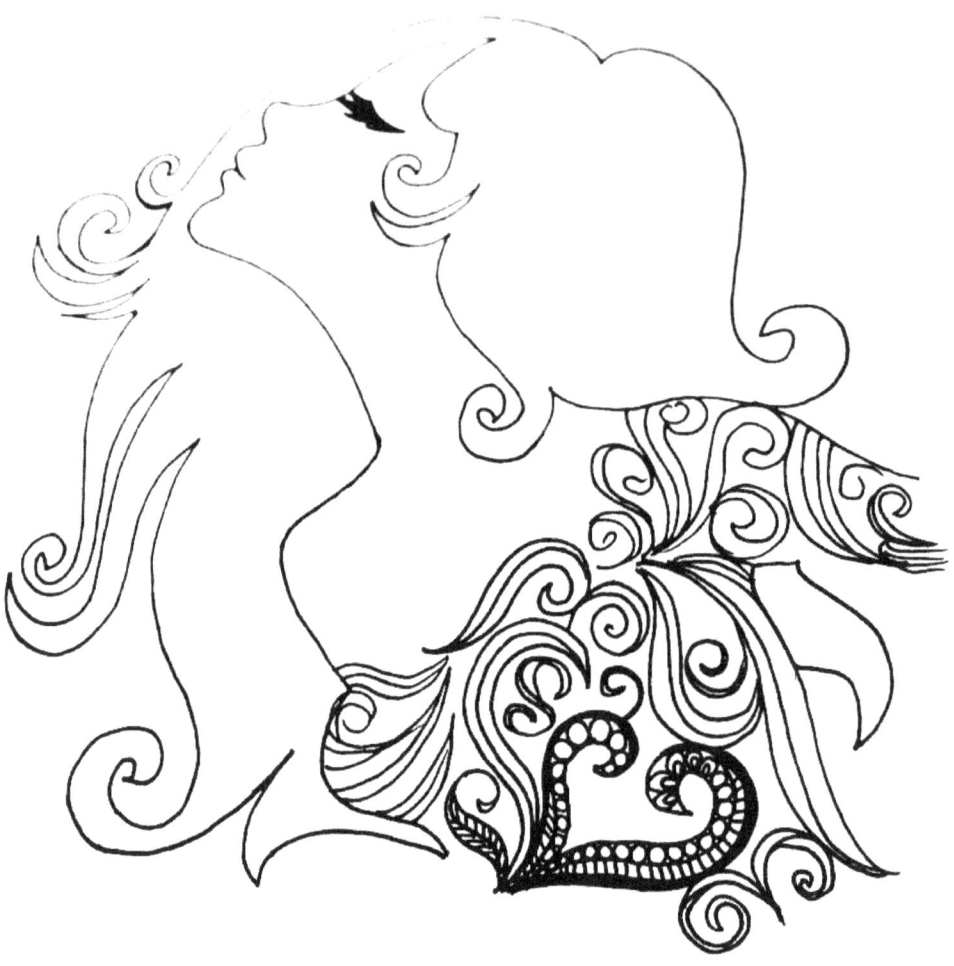

Step 8: At once you can start making more doodles inside the paper wallies (you can go back to the pencil for this one, later you will be inking it, -also if you are still not comfortable using your full arm, you can draw the details just using your hand and wrist-)

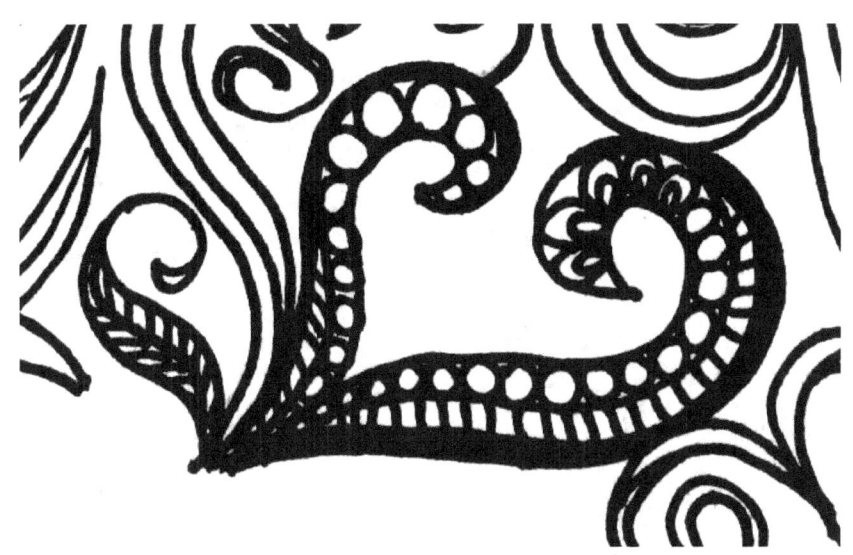

Step 9: Once you have the paper wallies ready you can start inking, do it in a way that you respect the outlines and shape, but not so in a way that gives depth, this sort of work is more on the plain side of things. Keep in mind that you can use different pens with a wide variation of tips for this job. Use wider points for the things you can remark and finer ones for those smaller details.

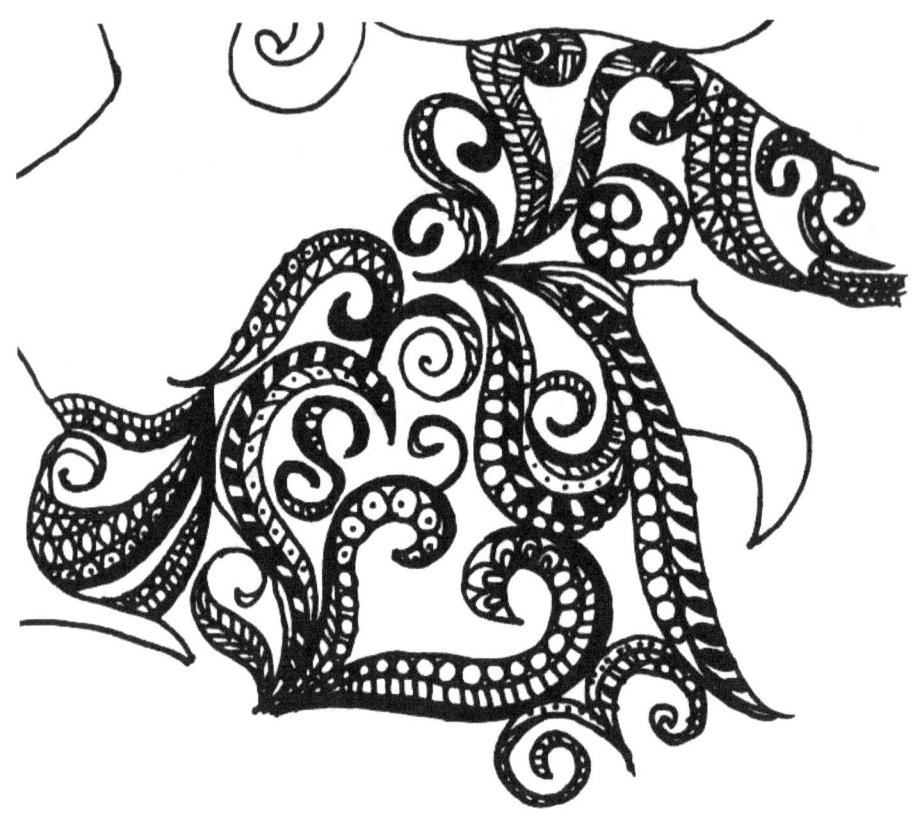

Step 10: Immediately after you can add some flecks with your roller pen in the unused slots. See how more lively is this looking already?

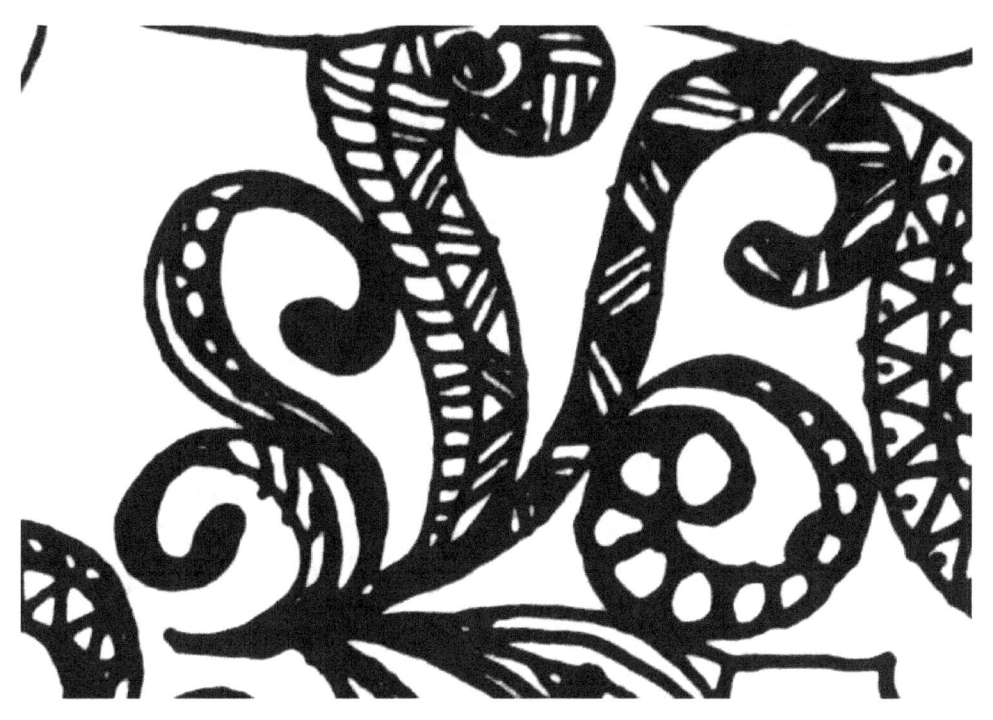

Step 11: Take your marker and start painting the area of the hair with it, be careful with the tracing; work in a way that no place is left without ink. If you want you can use the markers to also draw the eyelashes, use it for the wider sections, and the pens for the tips. For illustration view the following pictures:

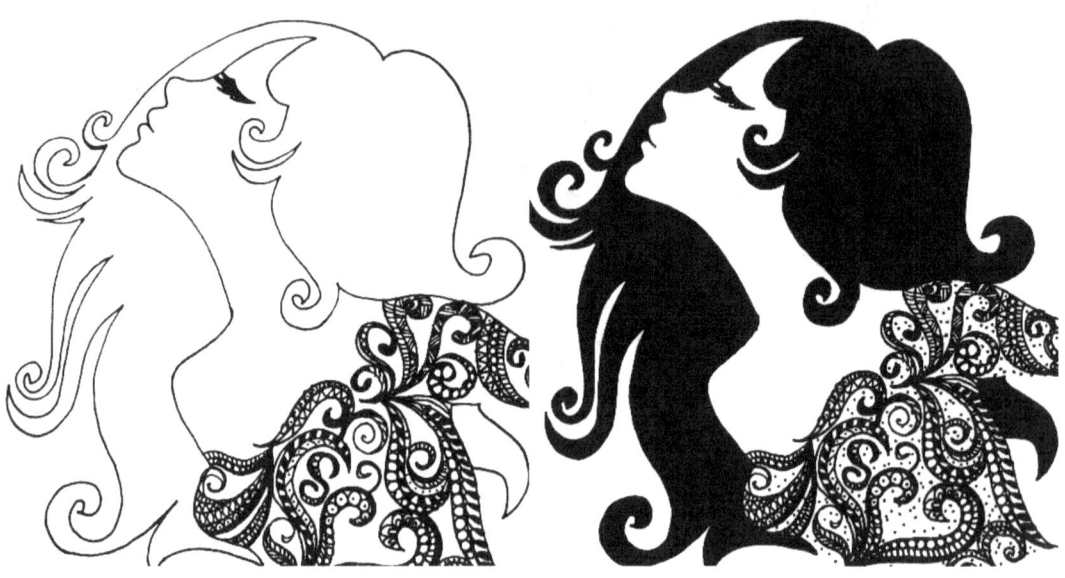

Step 12: Do a paper wellie for the waistline; you can achieve this by drawing two or three parallel lines, or also by doodling circles inside of two lines. If you feel comfortable with the pen you can do this with it.

Step 13: Continuing with the picture above, we will be adding long curved lines from the waist downwards, this will be widely separated from each other, and the idea is to get something that will look as a skirt. Once this is done start making waves inside this empty places, play with the patterns. Ensuing this you can do the same with all the spaces of the *skirt*. This how it may look:

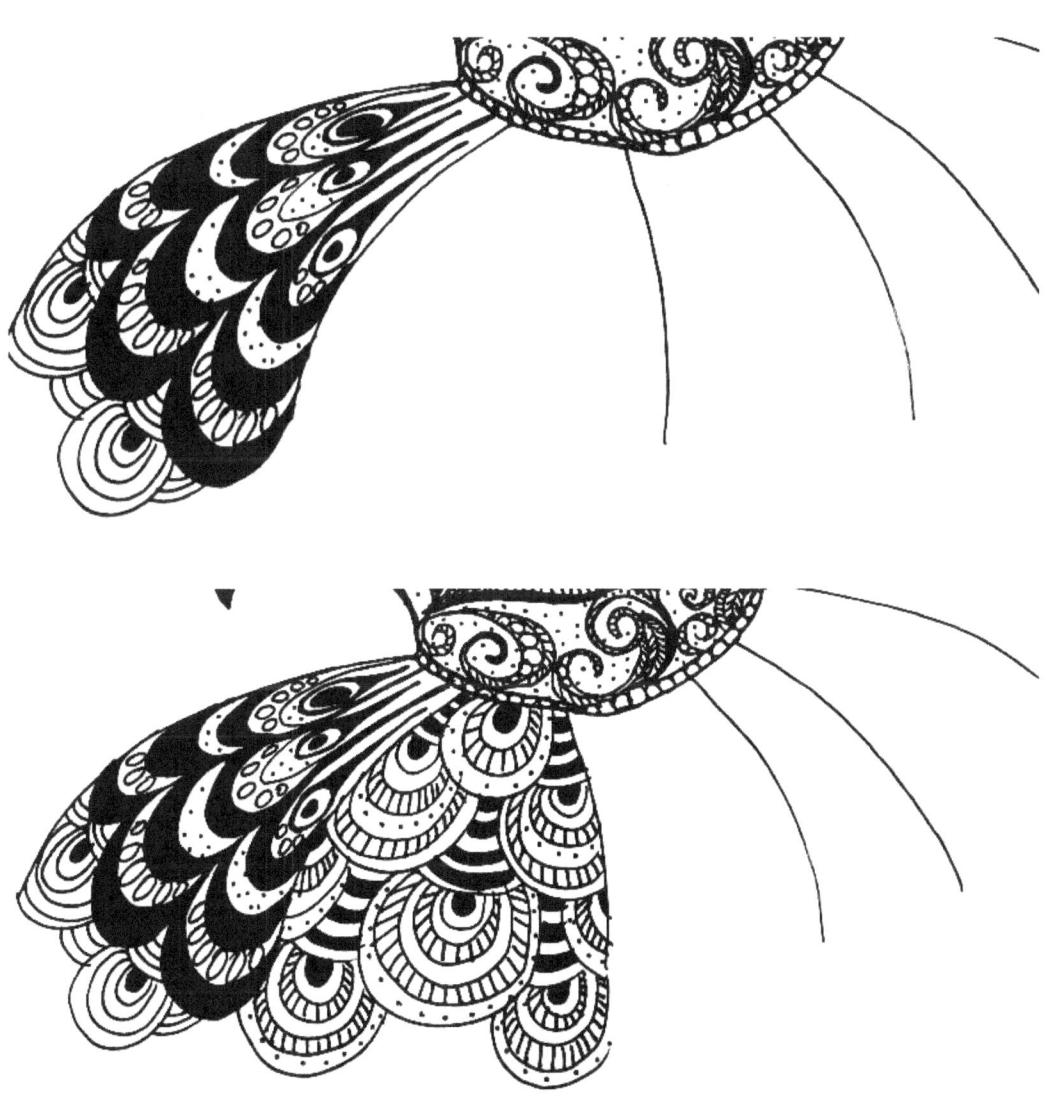

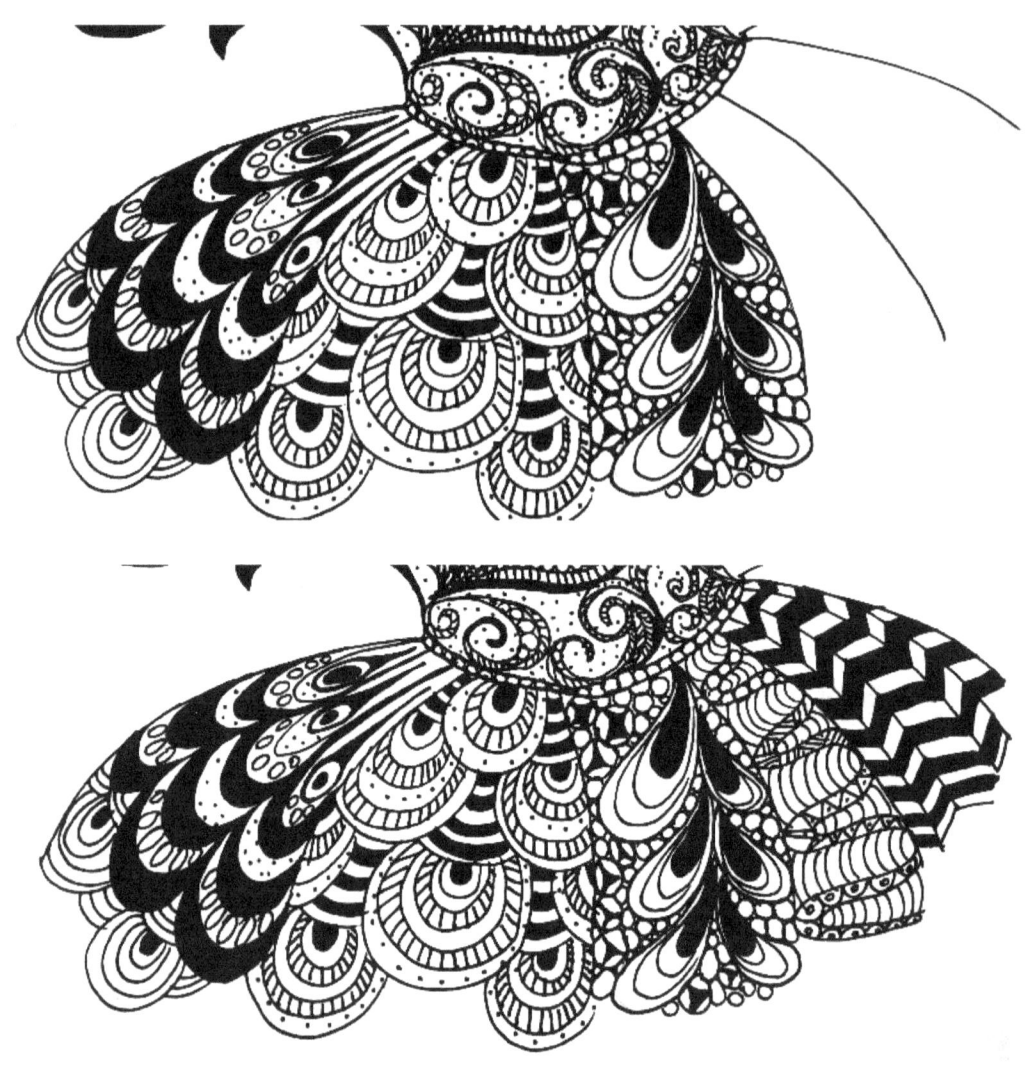

Step 14: Before you notice, you will have completed the skirt you can start inking and painting with markers. You can also follow the peacock inspirational design. Details below:

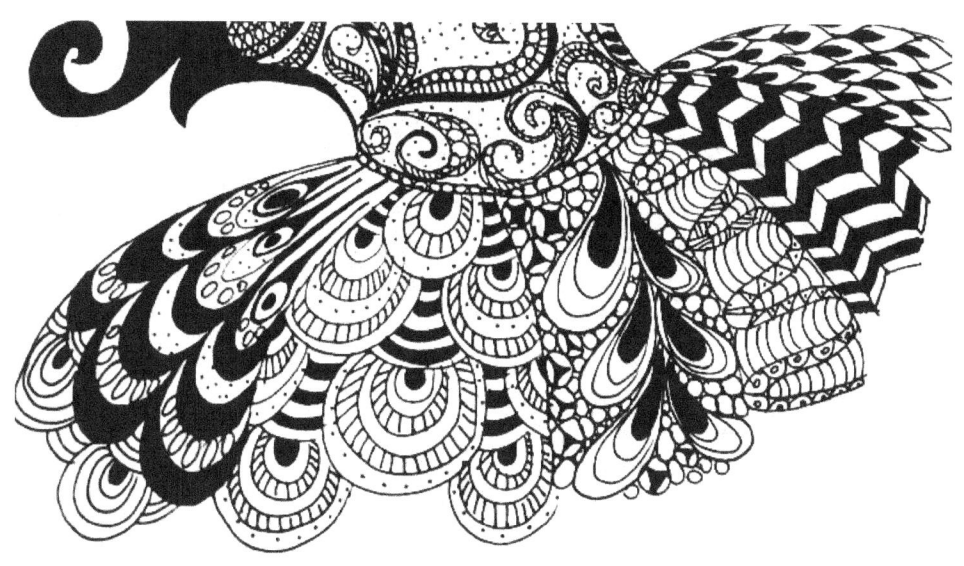

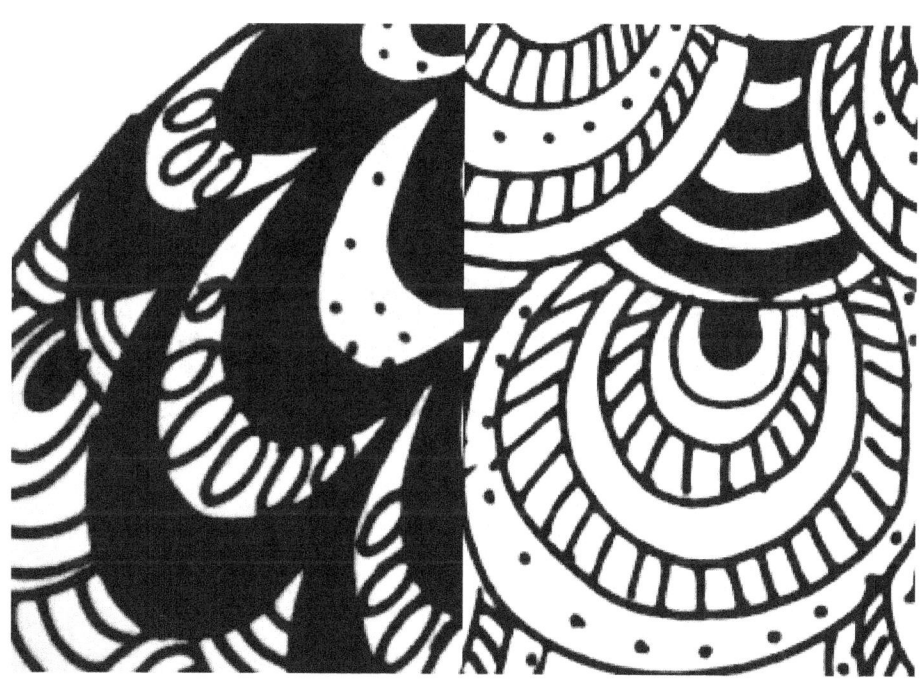

Lesson Two: The fairy

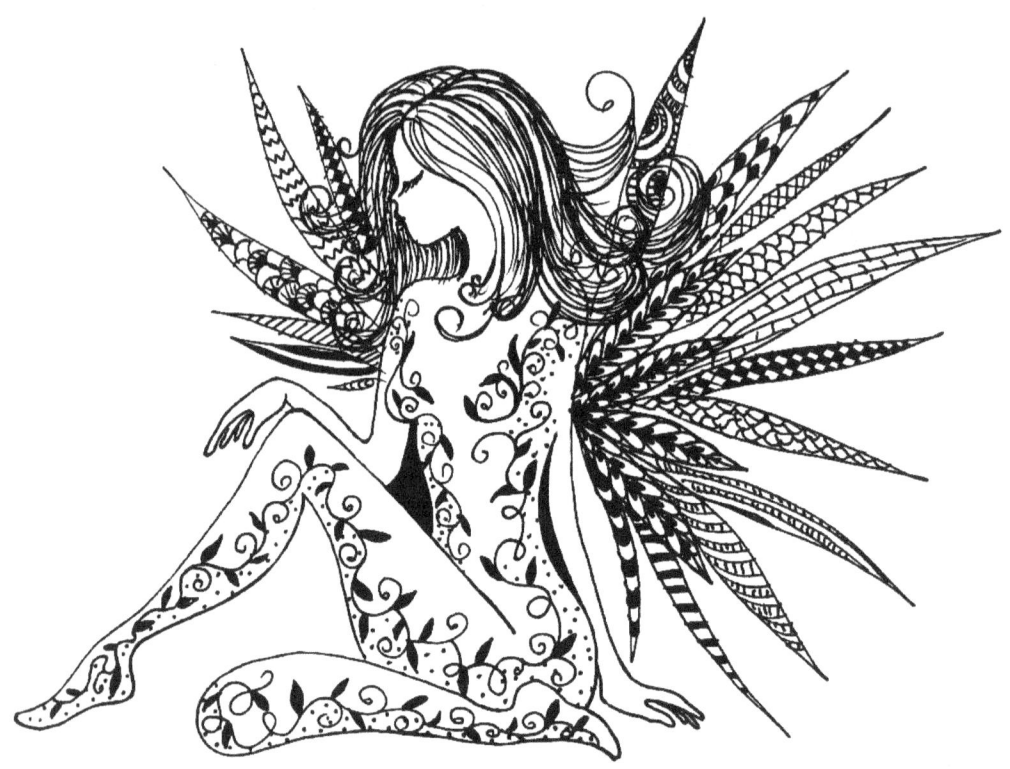

Step 1: We bet that just by glancing at this creature you have thought that it would be better to take a look at anatomy books, mostly those with illustrations. If you are going on that route you will be on the right path. That will be our first step study the anatomy of the women body.

Step 2: Now that you have a better a grasp of the human figure. The task at hand is doing the guiding lines, similar to the ones used on the prior lesson. This time we will using a long curved vertical line that will serve for the space from the waist to the head. Another two lines with deepen curves going horizontally will serve as outliers for the legs.

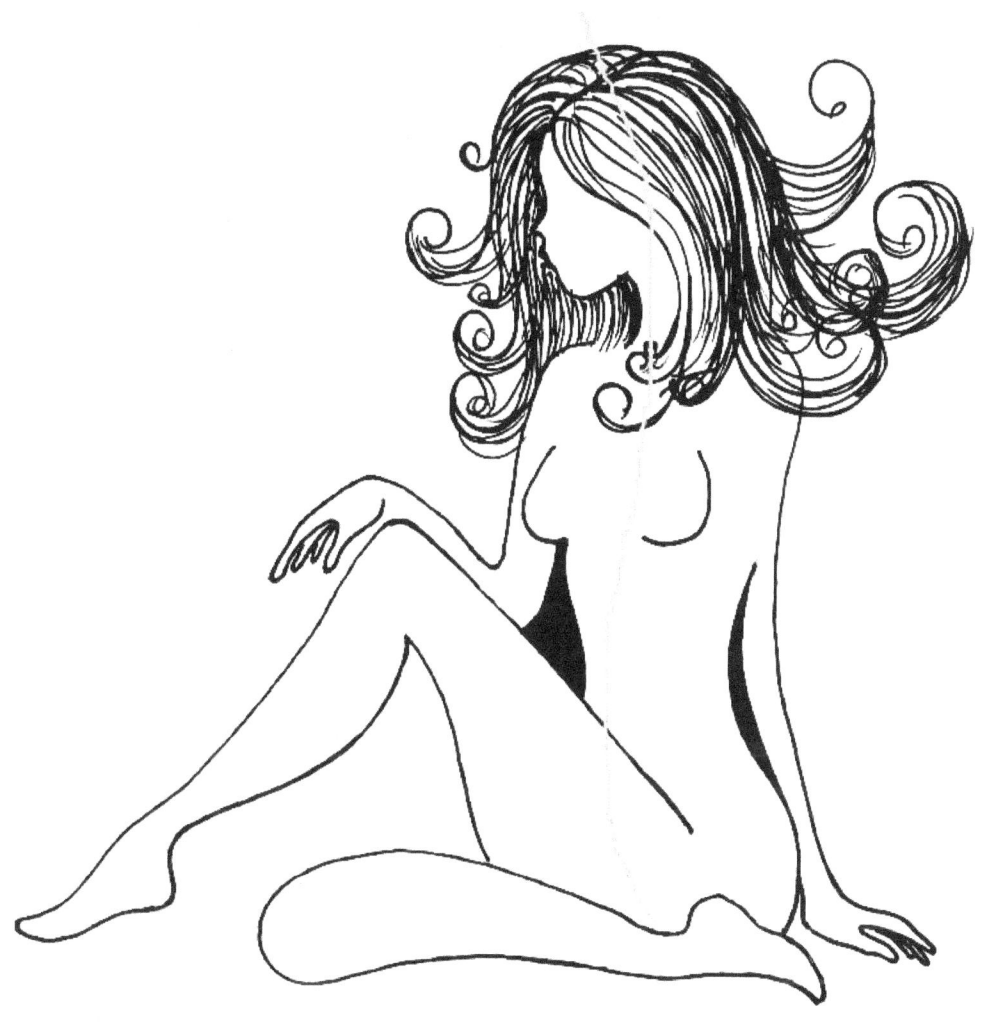

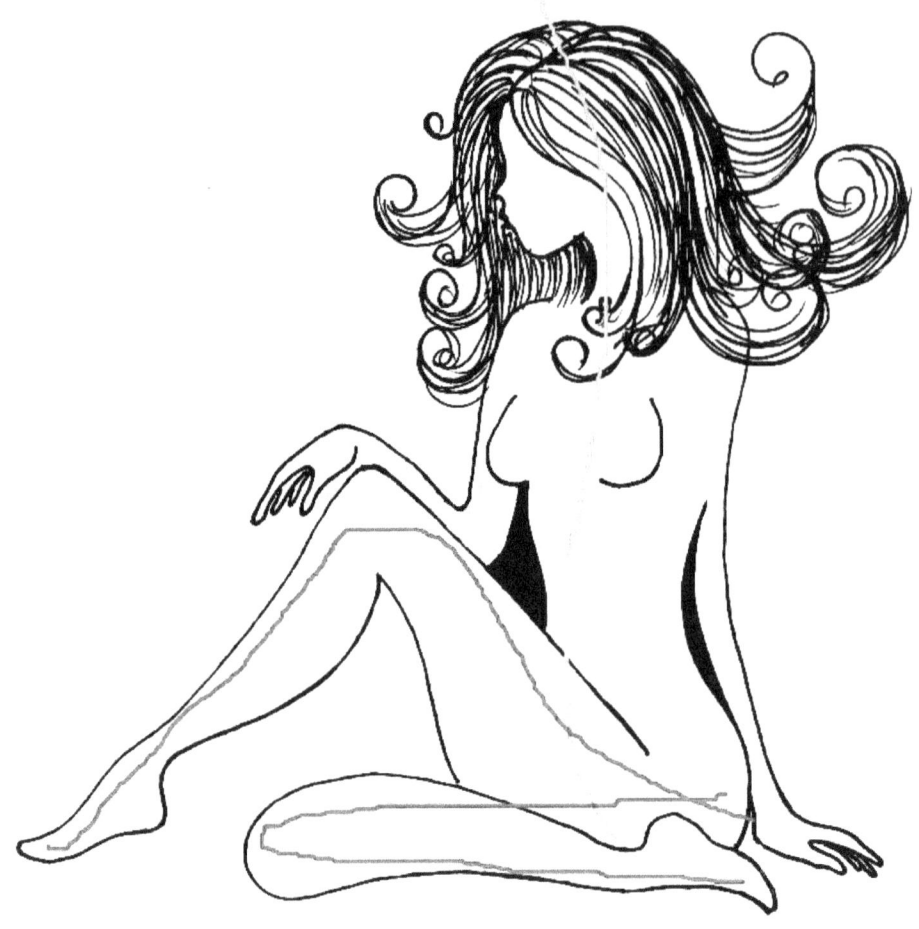

Step 3: This is quite a curvilinear shaped character, right? Try to have that in mind while you are encapsulating the figure in simplistic forms; meaning that you will need to use round and arched models for this effort. Now that this is ready you can start drawing in the space inside the figures. By doing this you avoid losing sight of the proportions. See the example below:

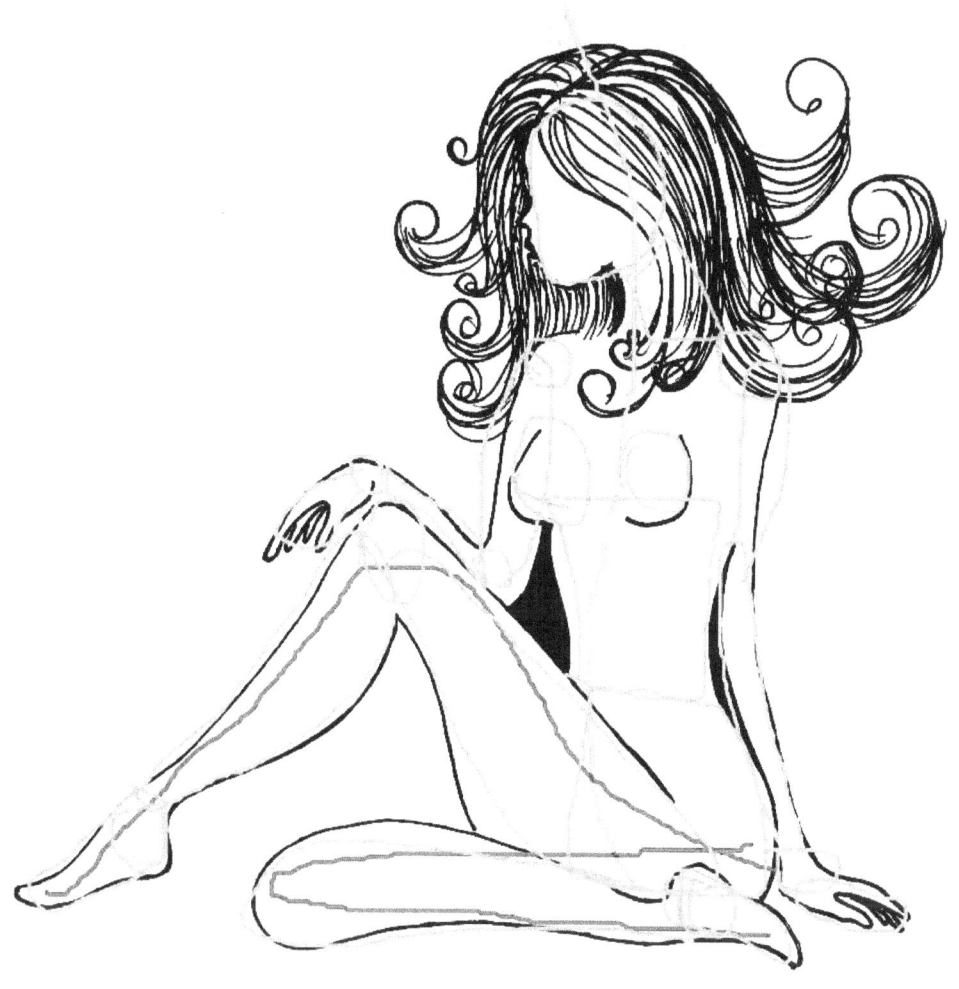

Step 4: As you can clearly see on the preceding figure we have two things missing - the hair and the wings. It is suggested for both to do a leap of faith and just use the pen. You can do depict the hairstyle by the use of wiggling lines-it will be far smoother to just use the pen, than to doing the same amount of work twice-; remember that the more lines you make the more *real* the hair will appear to be.

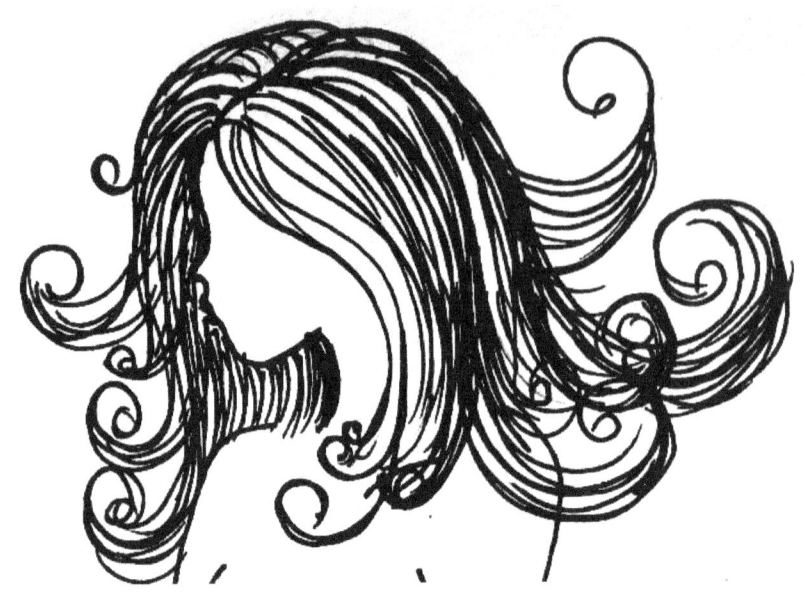

Step 5: With the wings the approach is simple, think of leafs when drawing them, put yourself somewhere behind the back of this pixie and start drawing two sets of lines that will be joined together at the beginning and again at the final part. Do various of these, make them of various sizes; preferably draw the tinier ones nearer to the creature, so that the larger wings will appear to be sprouting from the back, more than that it will give the whole composition a bigger dimension.

Step 4: Now we will be concentrating our efforts on the hands, do be careful when approaching this task. As it was done with the entire body, take your time to examine your own hands; you can leave the arms without the hands with no problem. You already have the shapes that will encapsulate them, so at least you will not have to preoccupy over the overall proportions failing. To make this an uncomplicated business you can cheat- we did just suggest for you to cheat- by making these fairy with cartoony four fingered hands instead of four (it not may seem as much, but this one missing finger can make things that so much sleeker)

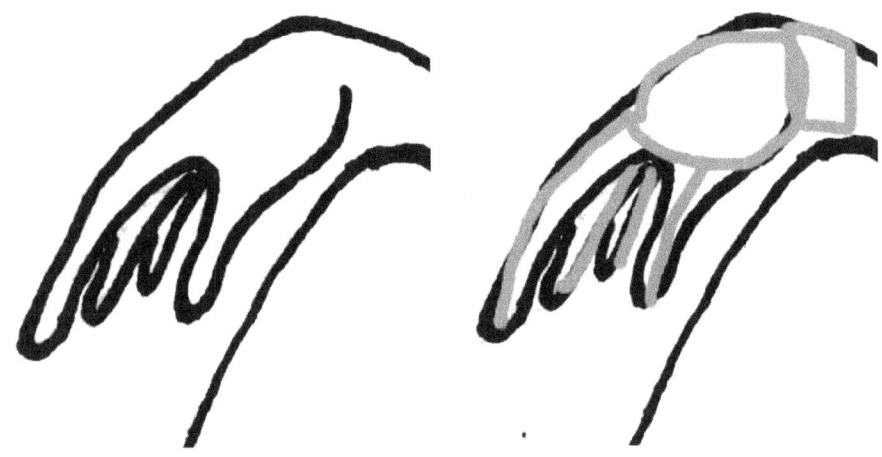

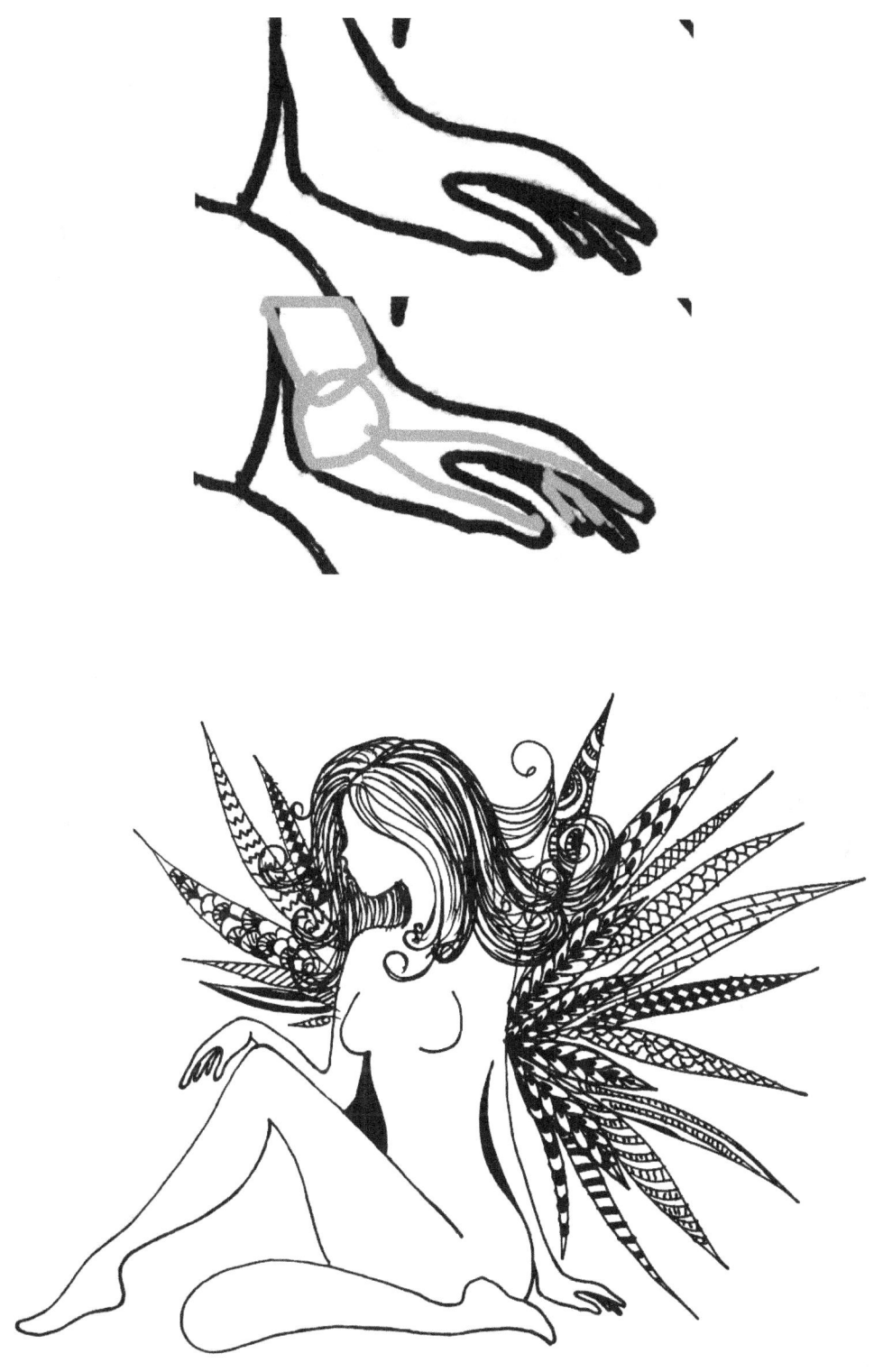

Step 5: With your inking pen do take a risk and start doodling inside the wings. A good idea would be as it is illustrated above, to fill more the appendages nearer to the back, you can easily use the marker to fill the spaces with more ease. For the other feathers you can project lines that are more separated, giving it a sensation of more expansion between them. Likewise alternating the wings that are filled with inked drawings, with those that are just linear, can serve on the service of giving a false sensation of deepness.

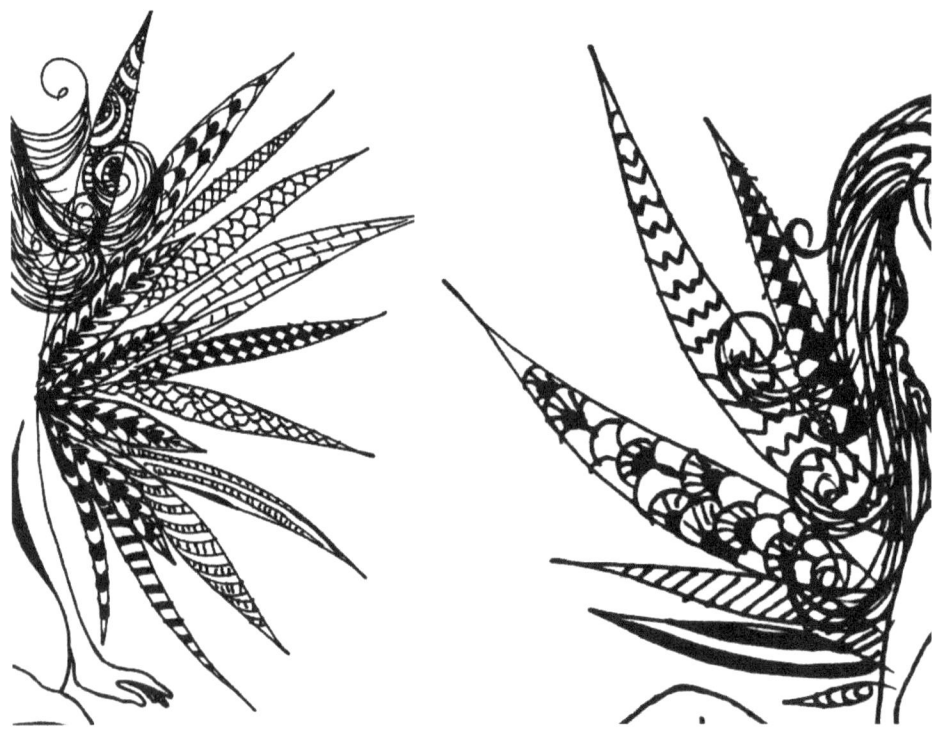

Step 6: Do not put your pen just yet, start delineating the image, and do it by using one single line. I know this a bit later, but please do not sketch lines, do one single line, as if you are following the figure with your shoulder. Yes, we are returning to that, do not think we are seeking to be aggravating; we just want to teach you knew things.

Step 7: Still holding the pen and with the marker at hand? Good! Now it is the time to let your hand run loose, wiggle, doodle, and just have fun. Not even kidding here; see the figure down below? Well, it does not exactly have an intrinsic design. Does it? No. It is just lines and curves. It is conceivable that this is galvanized by bindweed. This can be used to fake clothes for this nude creature.

Step 8: Just draw dots, do not ponder too much about how to make them; well, if you want to be more precise, you will see that in the picture overhead, the dots can be used as mechanism for generating shadows.

Step 9: Draw the imp's eyelashes, and with a marker fill the spaces between the body and the arms.

Lesson Three: Missing miss amidst the mist

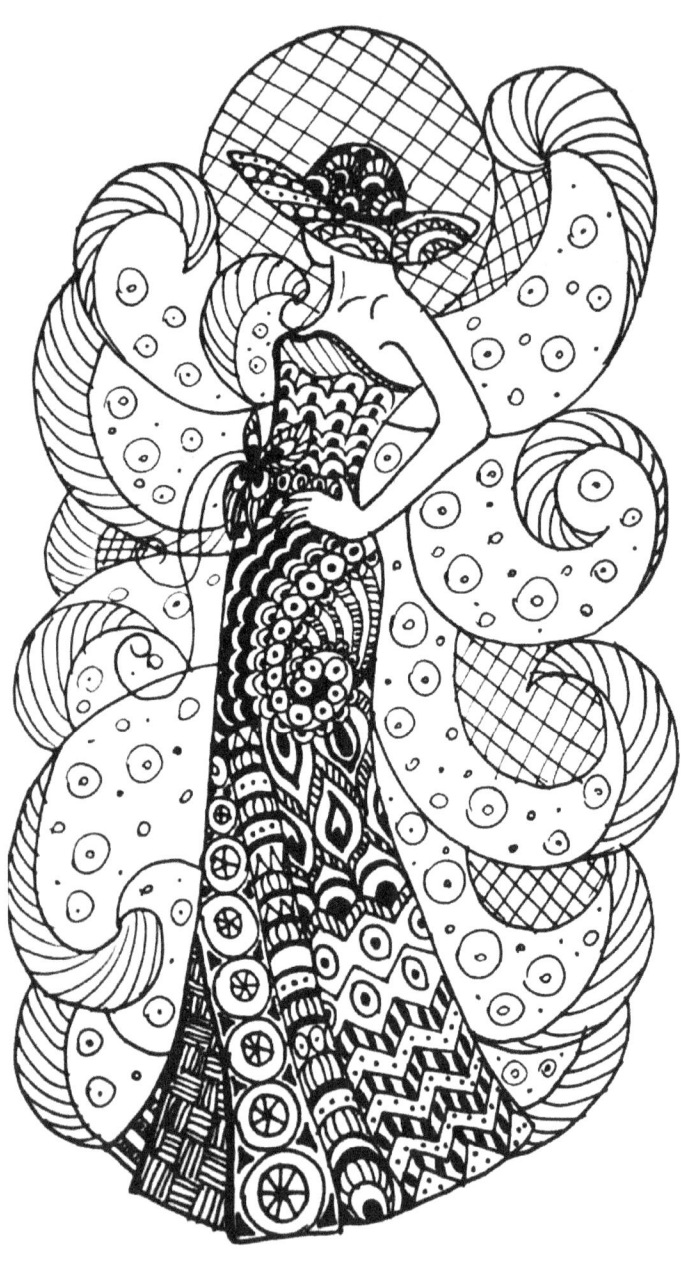

Step 1: We do not like repeating ourselves, so here is the shorter version: study the figure, think about a woman's anatomy, draw the basic lines for the general shape of the body, and delineate the simplistic geometrical figures that will have the picture inside of it.

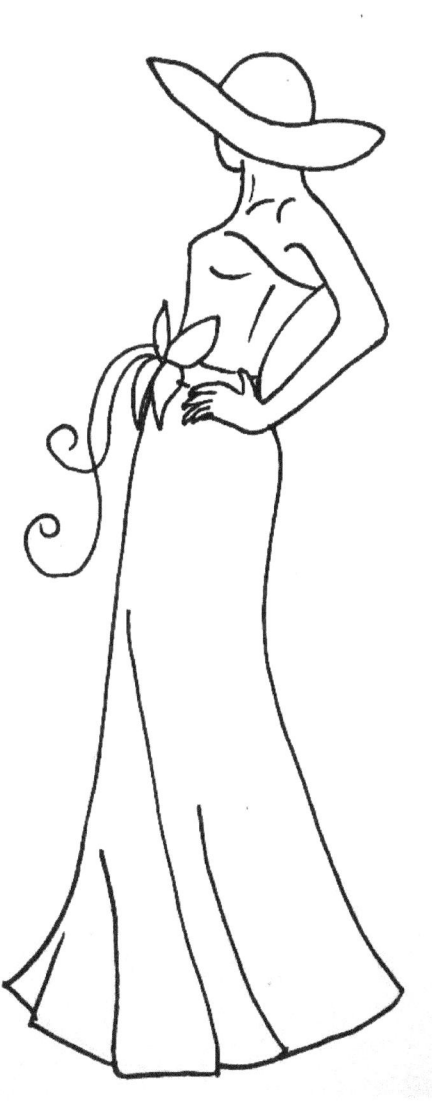

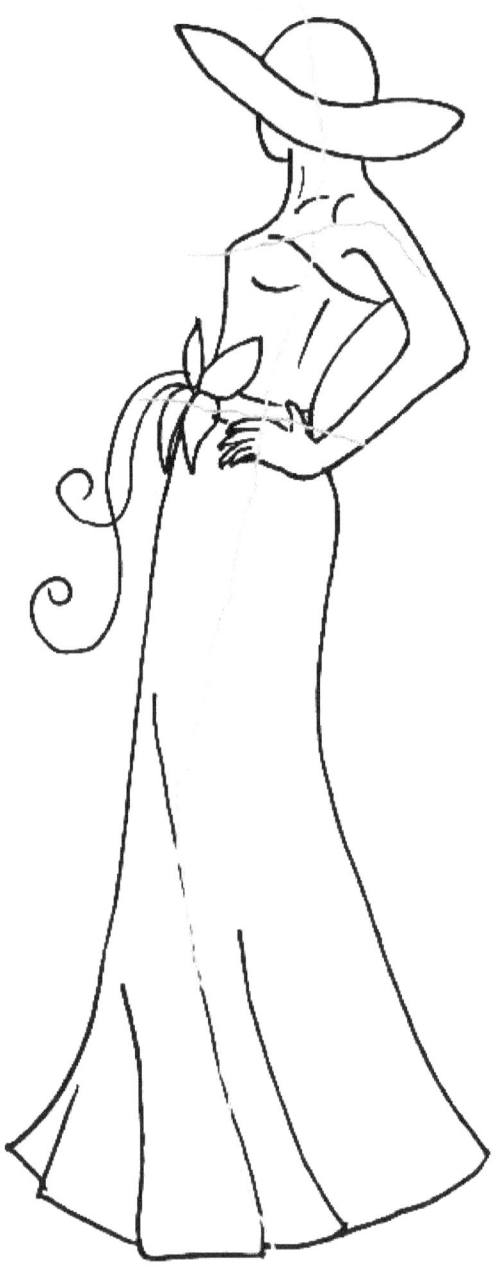

Step 2: Observing carefully the figure compose it in your own sheet. Pause, take your time, watch, wipeout those things that are not working and try again. To make this part of the process easier we will advise you to pay attention to the fact that the bottom part of the dress looks awfully like an stylized bell, take that on account when sketching it, as a shortcut. For the bust of this woman one can recall a small curved shaped glass. Furthermore, the entire body has an inclination that depicts a C if you contemplate with caution; this invisible line can also be of help in making this.

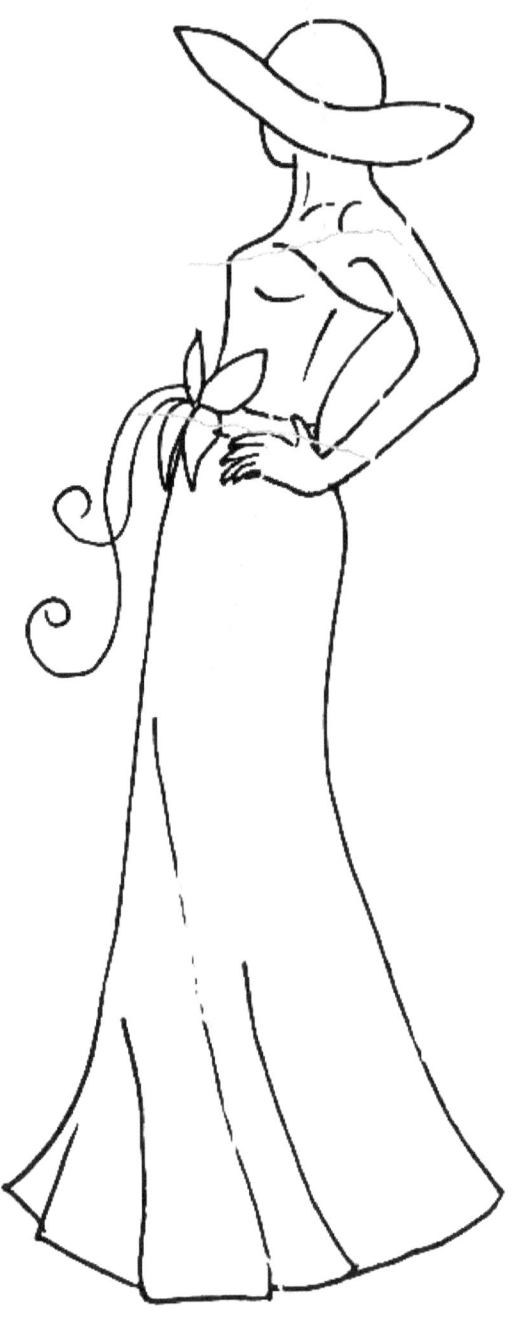

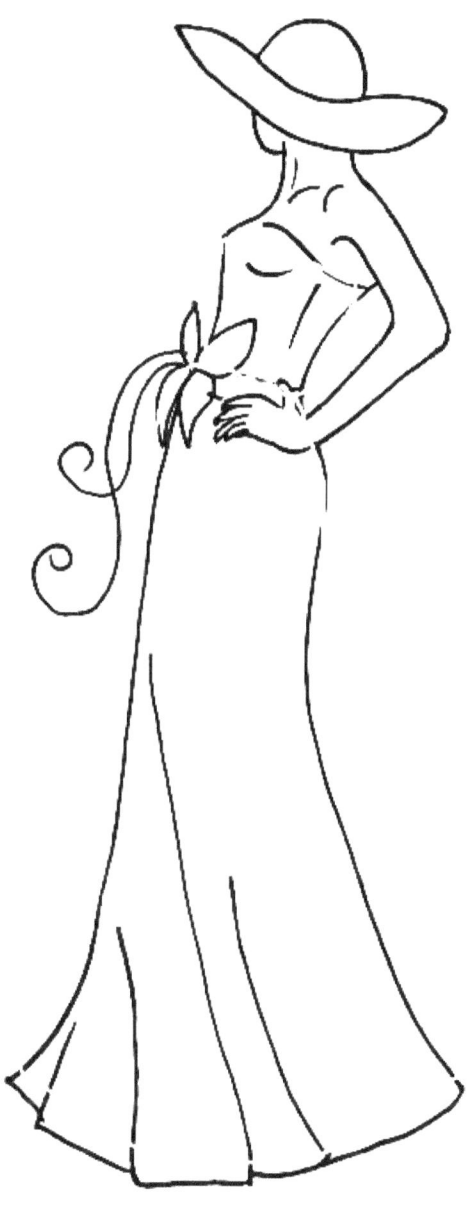

Step 3: Having outlined the piece, now we are going to concentrate on the fine points like the hat, bow, hands, and folds on the gown. Observe how the hand is positioned on the hip nearly touching the nod, also study it form. It does look clearly like a butterfly, or at least a slightly simplified version of one.

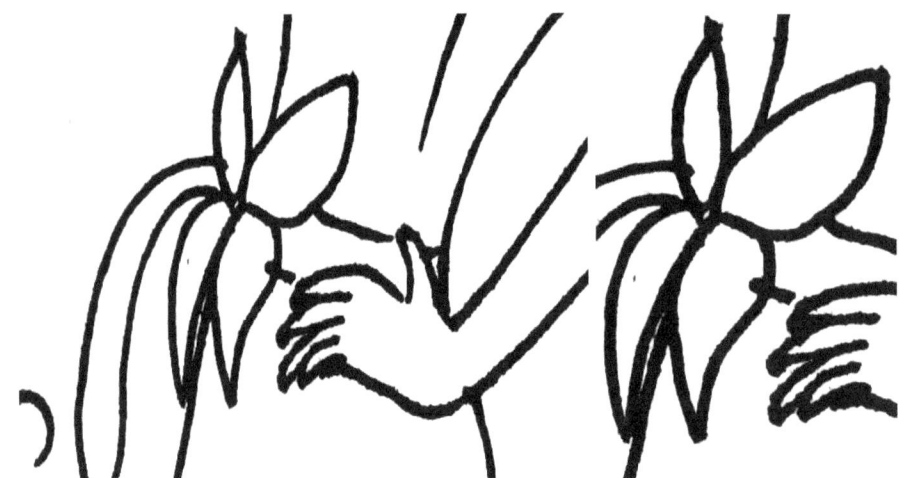

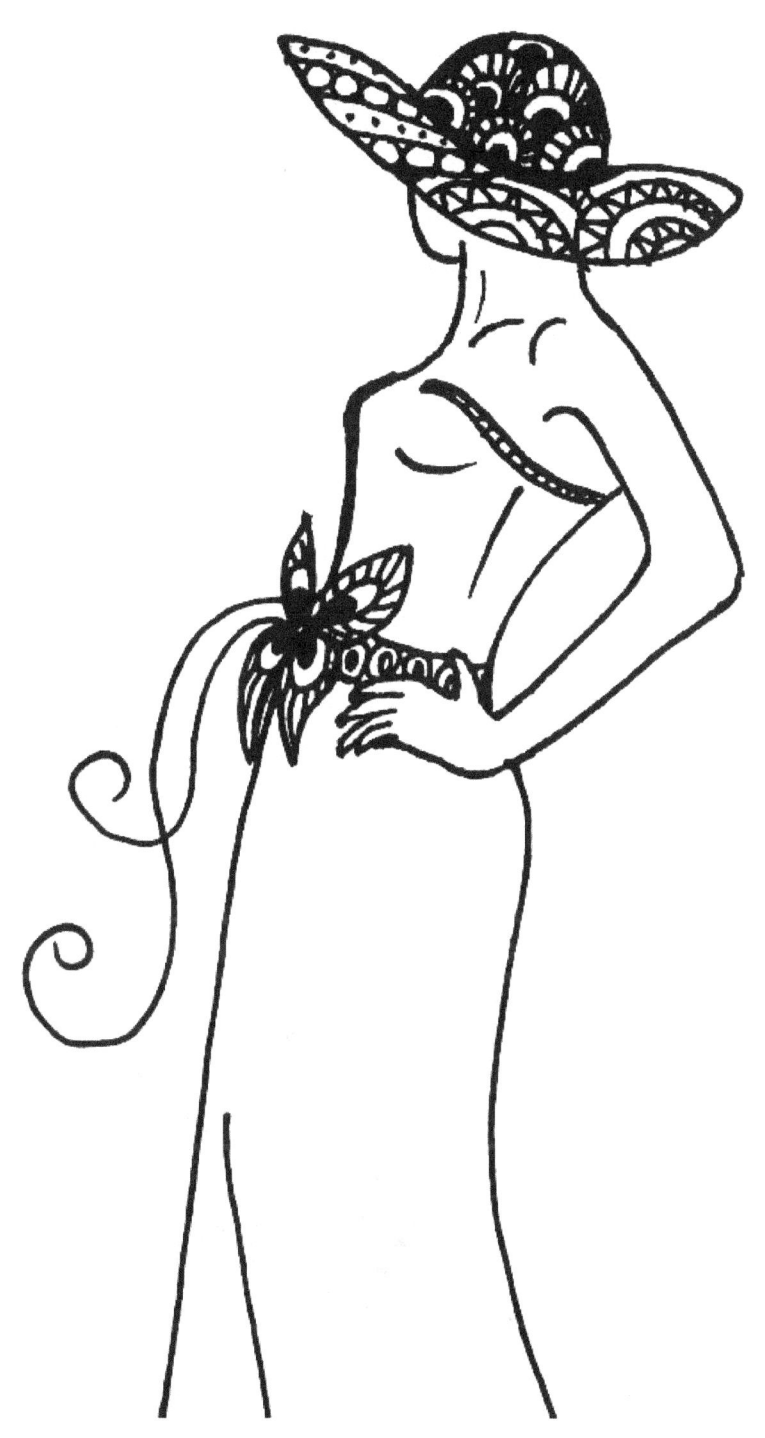

Step 4: We will focus on the hat. An engrossed line will use to divide the upper round shaped part from the wider lower part. Then make various lines, at least, four separate ones, near this draw parallel circles, and then repeat them next to each other, on the bottom side; in the round part draw more circles contacting one with the other. Next, you will need to ink the white parts left from the recently drawn figures, add some lines inside the equidistant semicircles, also you can do the same with the other circles on the hat. Just play with the marker here creating motives as you please.

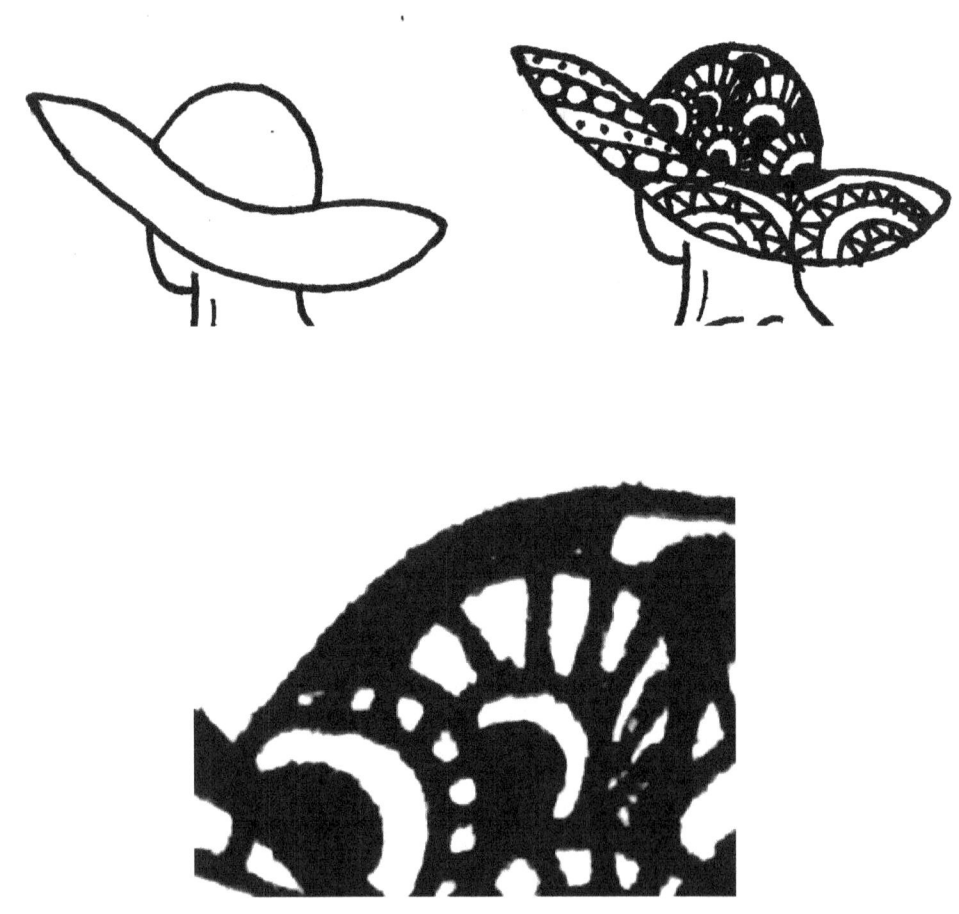

Step 5: We will kill two birds with one shot, well, actually three: the belt along with the bow and the detail on the bust, there right above the breast. For the last one, add a coextensive line close to it; subsequently start making circles inside of both that lines and the belt. After this following the shape of the butterfly making lines alongside each other; the next thing will be to sketch lines going around the shapes, and also the white space can be filled with the markers.

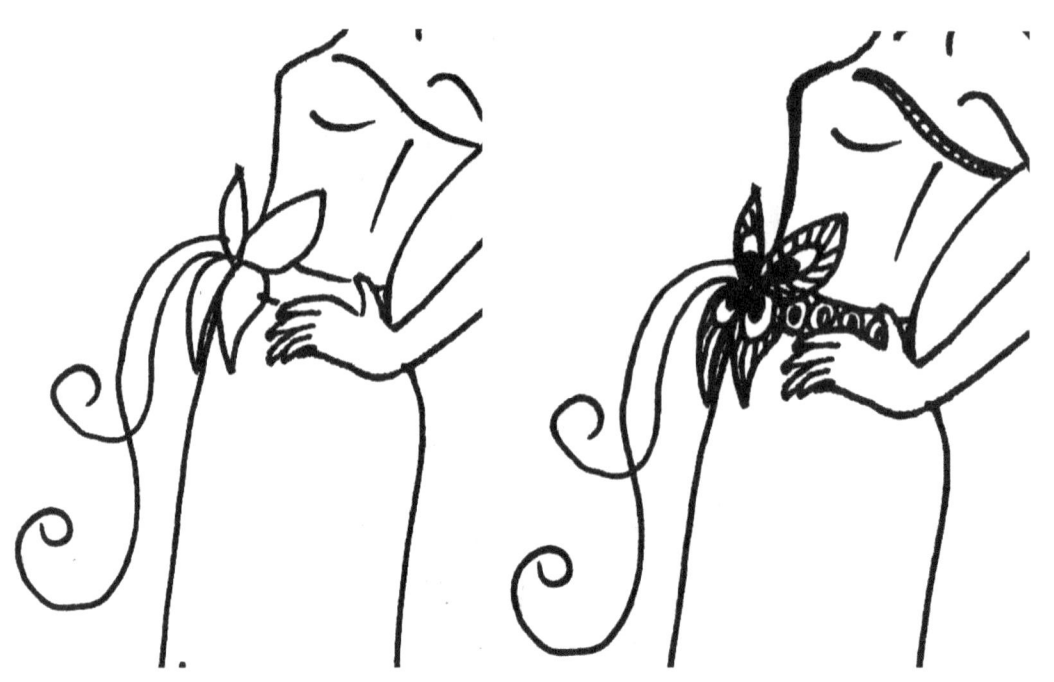

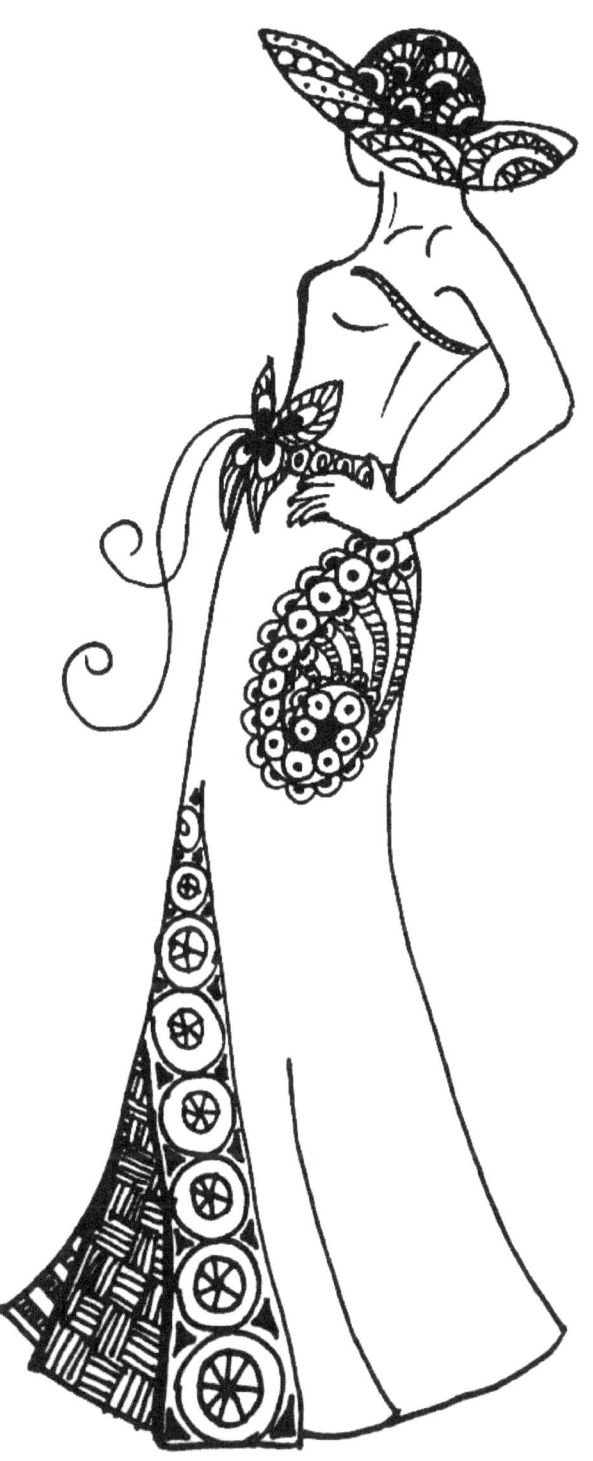

Step 6: Taking as an example the picture above, we will be adding an oval just below the hand, inside this oval draw a thick curved figurine, following parallel lines one after the other, with perpendicular bands drawn within. The reader can also get some inspiration from the world around and design models to fill the unused places of this round figure.

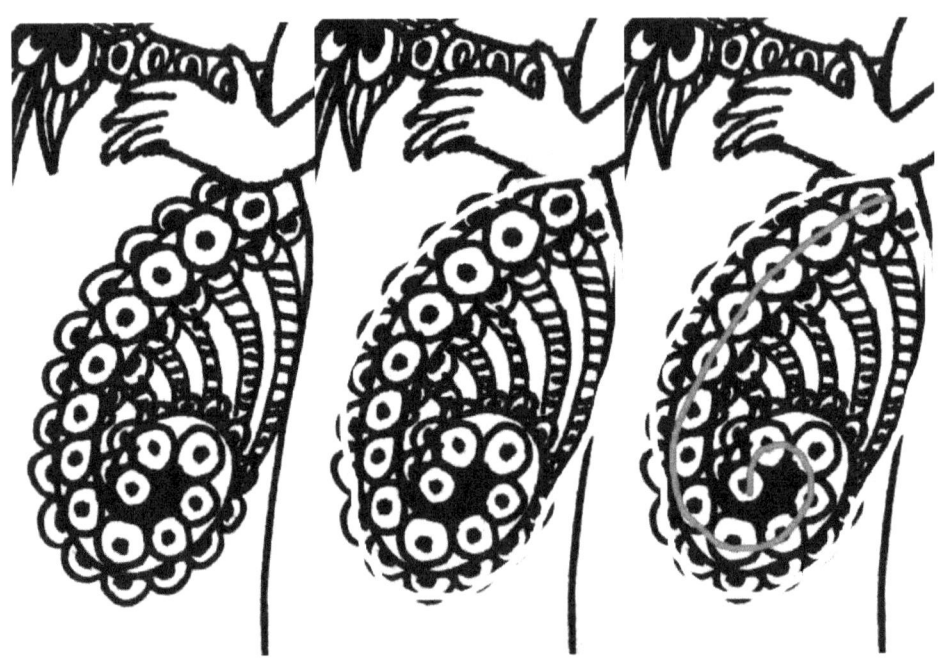

Step 7: Draw a small triangle and then a bigger one engulfing the other; with this we will create a rectangle shaped figure growing from the bottom up of the gown; inside of this draw circumscribed circles, two-one inside the other-, put them on a row going upside the attire, getting smaller and smaller as it gets nearer to the hip. From the minor circle center lines will appear. Inside the triangle, sketch cheered pattern, inside the squares make vertical and horizontal lines, altering the them so that you will end up with a vertical and horizontal, so on. On the crease next to the triangle- that also creates its own; there make consecutives horizontal lines.

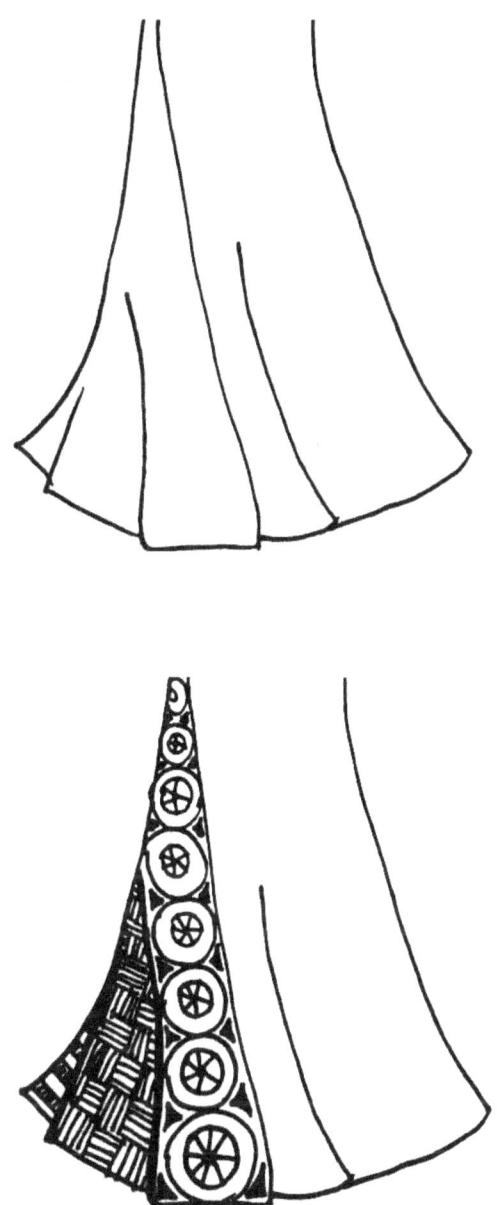

Step 8: With the previous stage finished, you can begin to outline the patterns just created, this can be do with the pen, preferably with a fine point. Adding to this use the broad tip pen so the parts that are seen as more important to stand out.

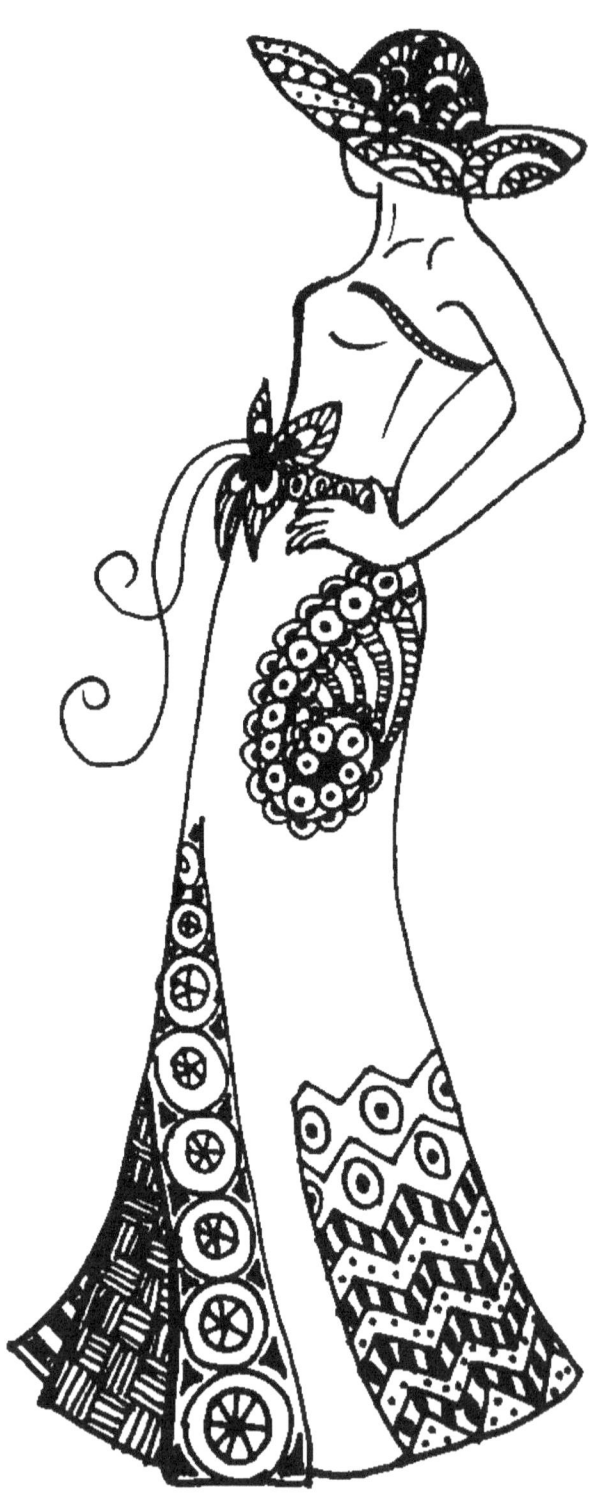

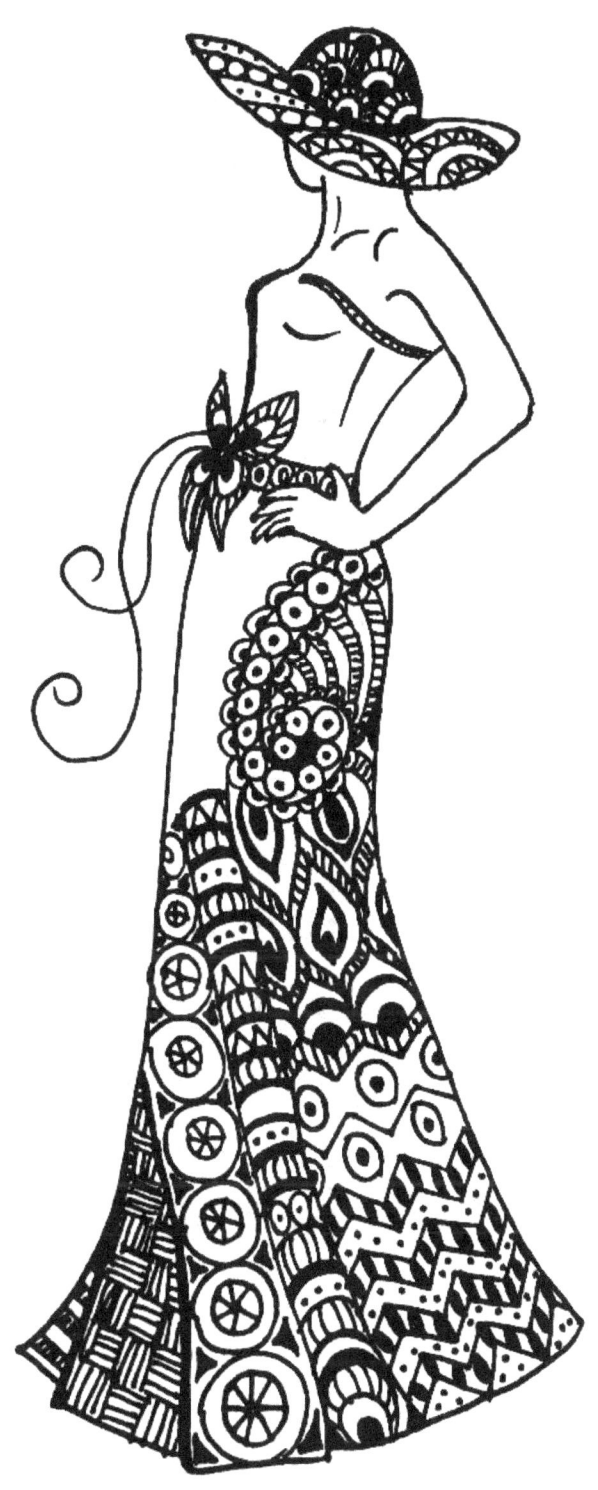

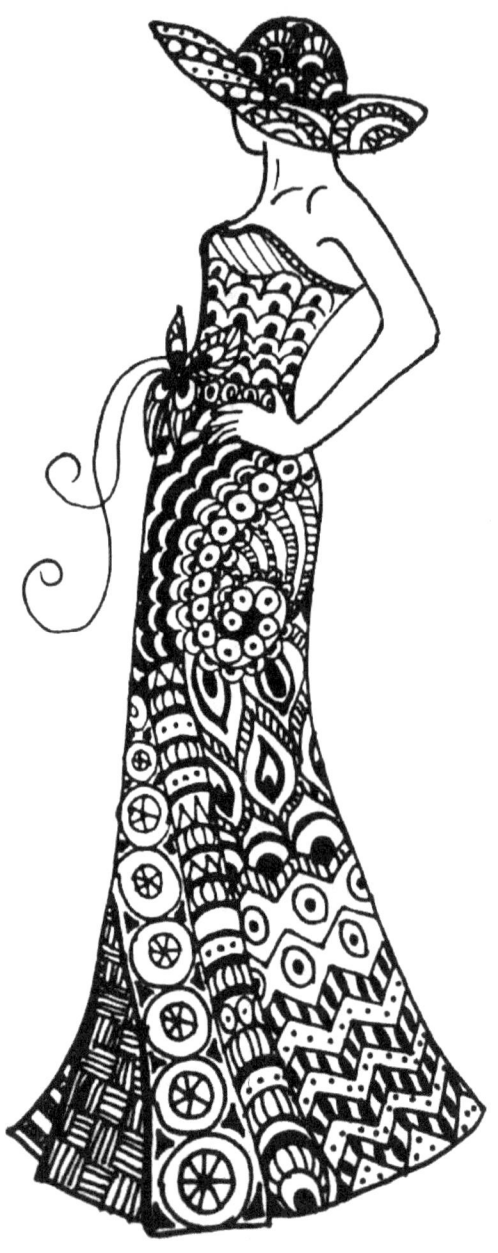

Step 9: On the bottom corner right, sketch grids inspired by indigenous designs as is seen in the first image of these three. Make at least seven consecutive rows of this; to differentiate each row, draw points inside one, and vertical lines that will have every other filled with black.

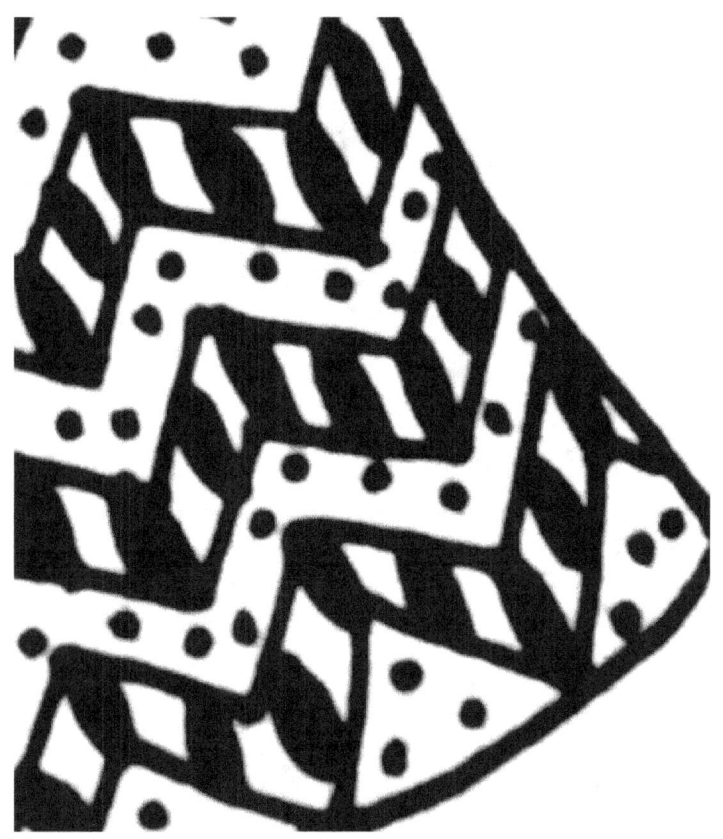

Step 10: Up top of these grids draw two rows of consecutives connected diamond shaped figurines; create them as separate sketches, and then erase the lines that separate them. Inside this new grids make circles, with points in the center of them that will be positioned in the center of the former diamonds.

Step 11: Following this, make another row like a straight lined waves, also it is a reminiscent of aboriginal drawings. Sketch vertical lines one after the other, to give the grid a simple visual texture.

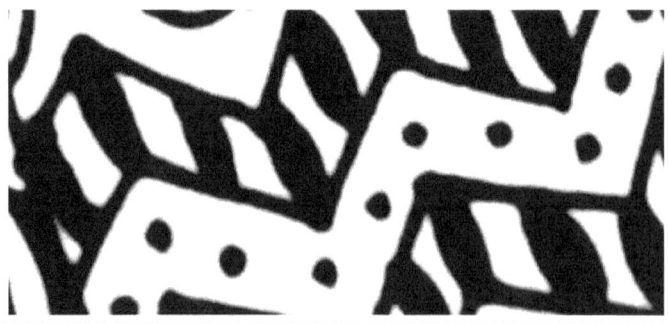

Step 12: Create two circles one next to the other, with four vertical strings of arcs coming on top of them. With that done, you can continue by making sketches of big rhombus like shaped object on a line, with other diamond figures hem in them; create two line ups one leg up the other (do pay attention to the fact that this have the appearance of a peacock plumage, or at least the feeling of it- plausibly this is not the last time you will encounter this motive in the design, and it is neither the first time, having ornamentation based upon this plumage all the way back in Lesson 1-).

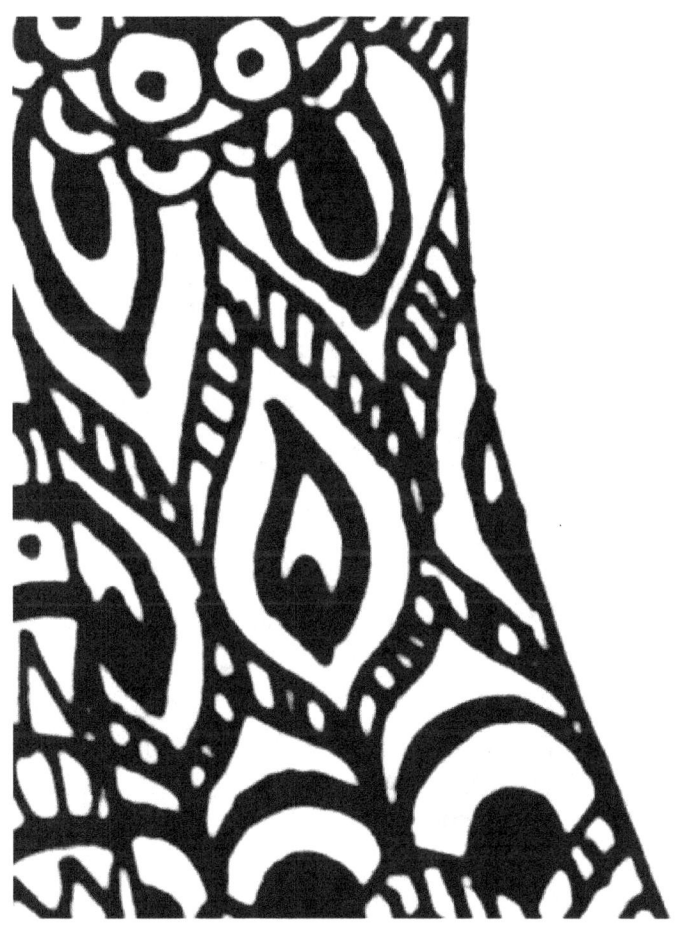

Step 13: Next to the rectangle we just explained draw another one, inside of it make successions of semicircular lines, with the basal one having another one circumscribed in it. To split each line you can create different motives within them. For example you can follow the design on the picture, drawing vertical lines succeeding with narrow black ones, and with triangle patterns.

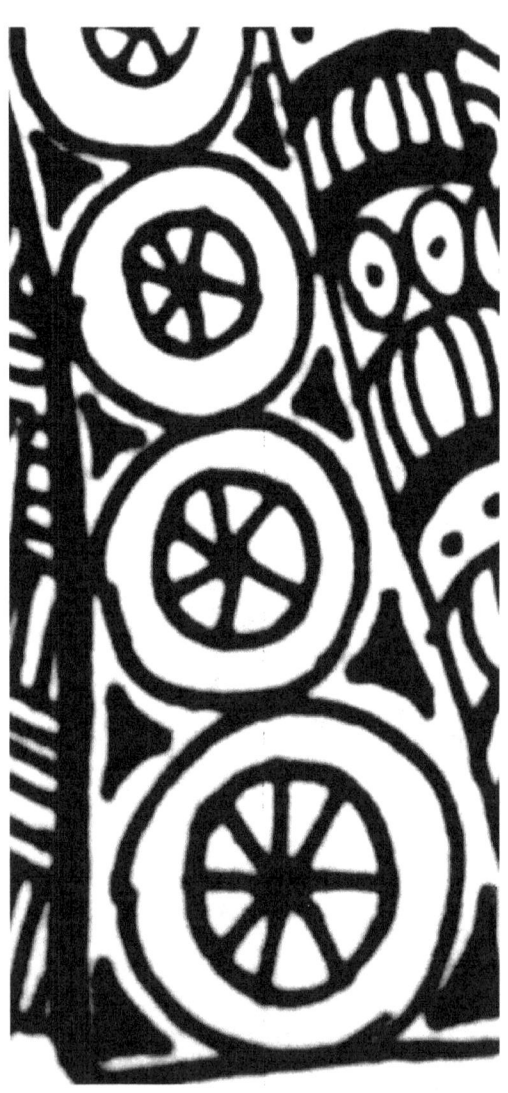

Step 14: Remember the oval, and the drawing created from it back in Step 6? Well, now you will need to draw long arced lines following the stamp given by the already mentioned figure; with at least six or seven vertical lines one after the other could suffice. Now that you have the parallel strings ready, start making small arcs one after the other on top of them, so that the impression while looking would be of waviness.

Step 15: Now you have filled the entirety of the ensemble with different and random patterns and motives; also, keeping the body of the woman intact (this should remain like this, so it can serve for the onlooker to differentiate between clothing and skin -it serves as neat trick to stylize the silhouette-). Your task now will be to start delineating the shapes that you want to keep of this drawing, and filling with black some of them so the contrast with white will make an interesting eye catching experience.

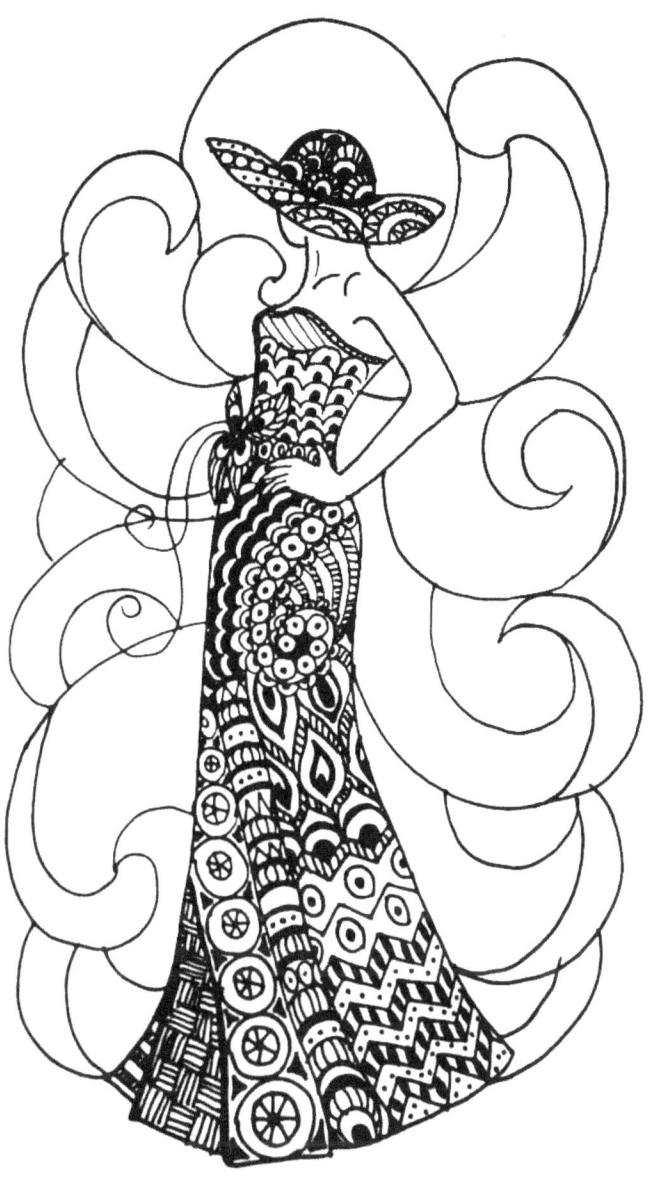

Step 16: As you can clearly observe on the image right overhead, the next step consist on creating a background. Because this art style doesn't work on depths, here the difference between the backdrop and the foreground is achieved via making the front image as the one with the most intrinsic patterned textured, while the other, will have a much simpler design to it.

Case and point being the curvilinear figures that apparently are coming from behind the lady, creating something similar to cartoonish clouds, having a tinge of Art Deco on their constitution. It is preferable to keep the sensation of quiet movement that this *clouds* have.

For doing this you can either just start sketching the lines necessary being careful about not messing the figure, that is if you are working with pen or marker from the start, if not you can commit errors and then erase. All another way out, and admittedly a cheat, would be creating the nimbuses on their page, cutting the figurine of the woman and pasting it there (Also, that would go against making this a tranquil exercise, and we are already dropping the ball with letting you use the eraser)

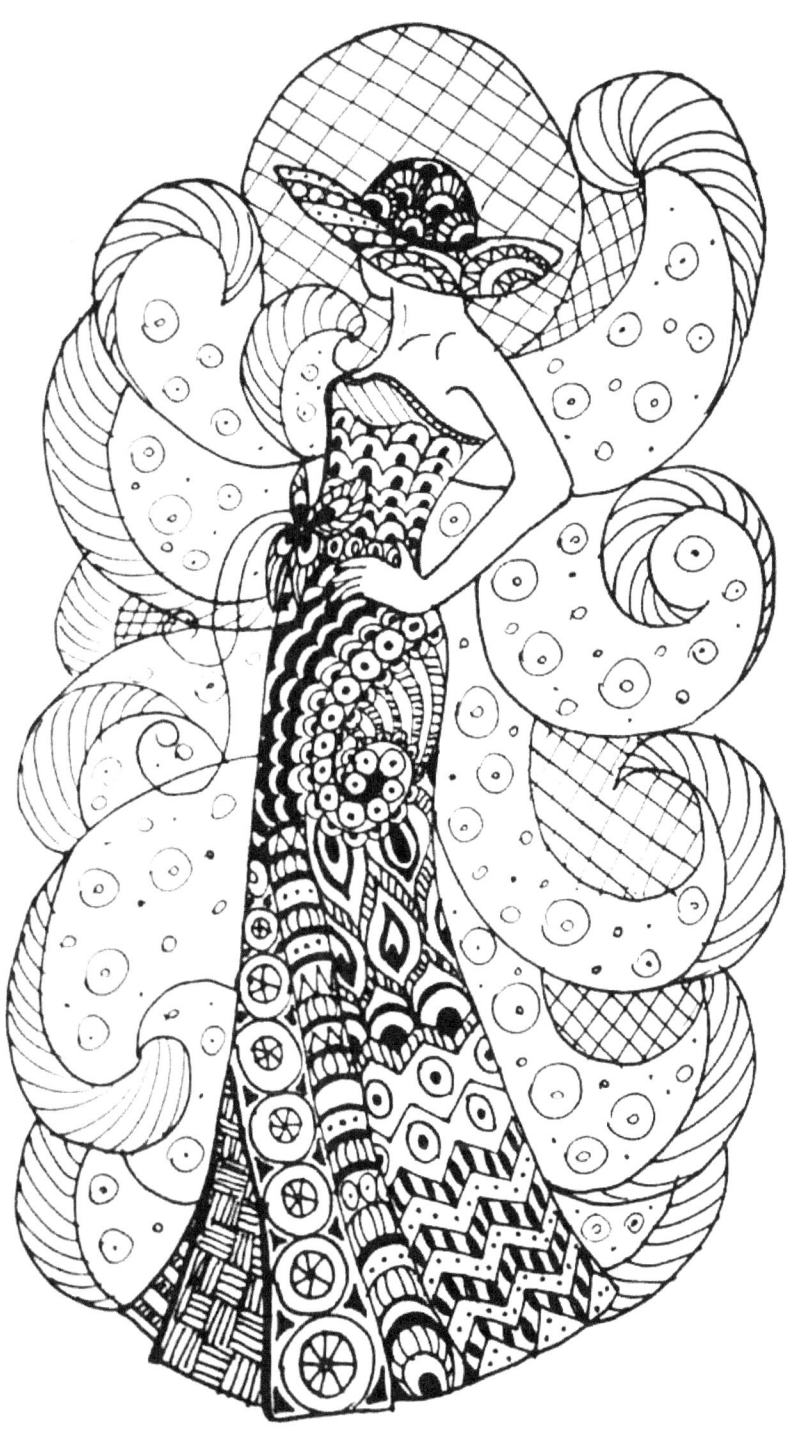

Step 17: Here you can see how the wider parts of this background drawings are to be permeated with circles of various sizes; also horizontal lines will have to be drawn inside the most stretch sections of them. For the places that are still blank we suggest for you to create netting- it will be a good idea, if you respect the original idea and do make a web behind the woman head, this will have as a result the characters head sticking out more. With this ready you can ink everything.

Lesson Four: A nightly butterfly

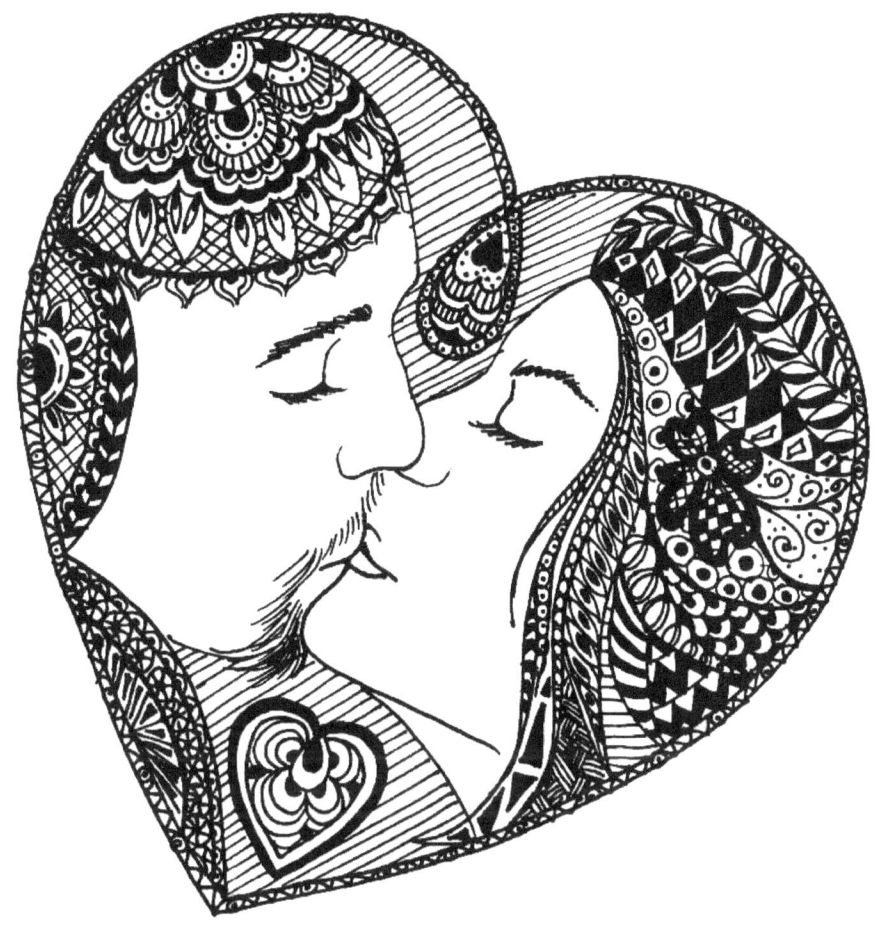

Step 1: We are finally integrating, even if it is just the faces more than one character to our mixture. As in previous examples it will be suitable for the reader to take time and observe the male and female face, and principally how does a profile look like. Working with a pencil, you can do the interior lines (one vertical line for the profile and nose, another four lines for the eyebrows, closed eyes, nostrils, and mouth-repeat the process with the other face-).

Having these ready you can start drawing the parts of the faces. Perhaps, you noticed how the man's face overlaps the woman's, which means that preferably you should outline his figure first. Then do the woman. Draw sketchy lines for the man's beard, by this manner it also can be achieved both characters eyebrows and eyelashes.

For the woman's locks long swirly lines can be used-make them in pairs and them make them joint on the tip-, make one of this grosser than the others, so later you can add tiny peacock like feathers motives inside of it. Follow the arced shape of the man hat, and the waved line of the lady hairgear. Take advantage of the semicircular shapes on the men and use it as a replacement for the shoulder. See the following picture as an example:

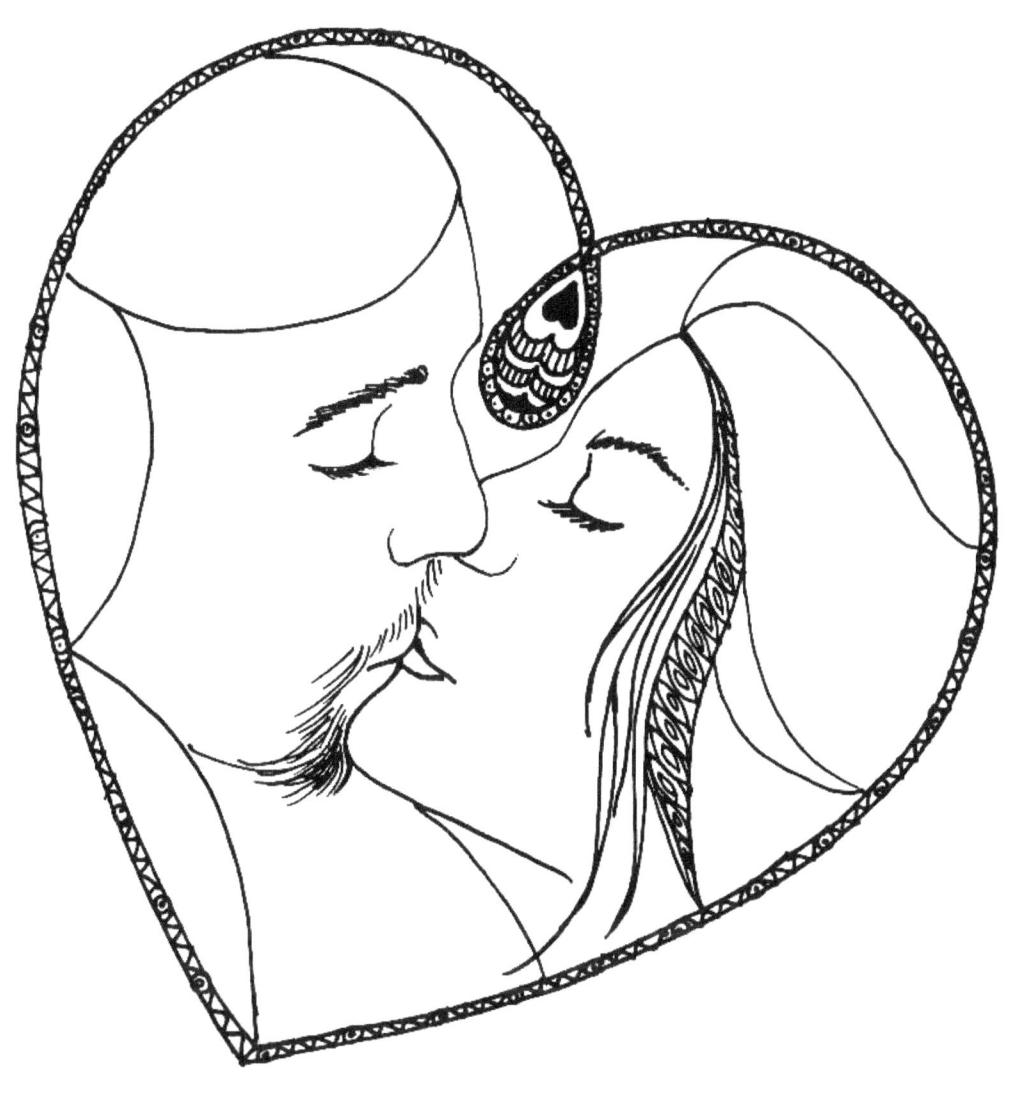

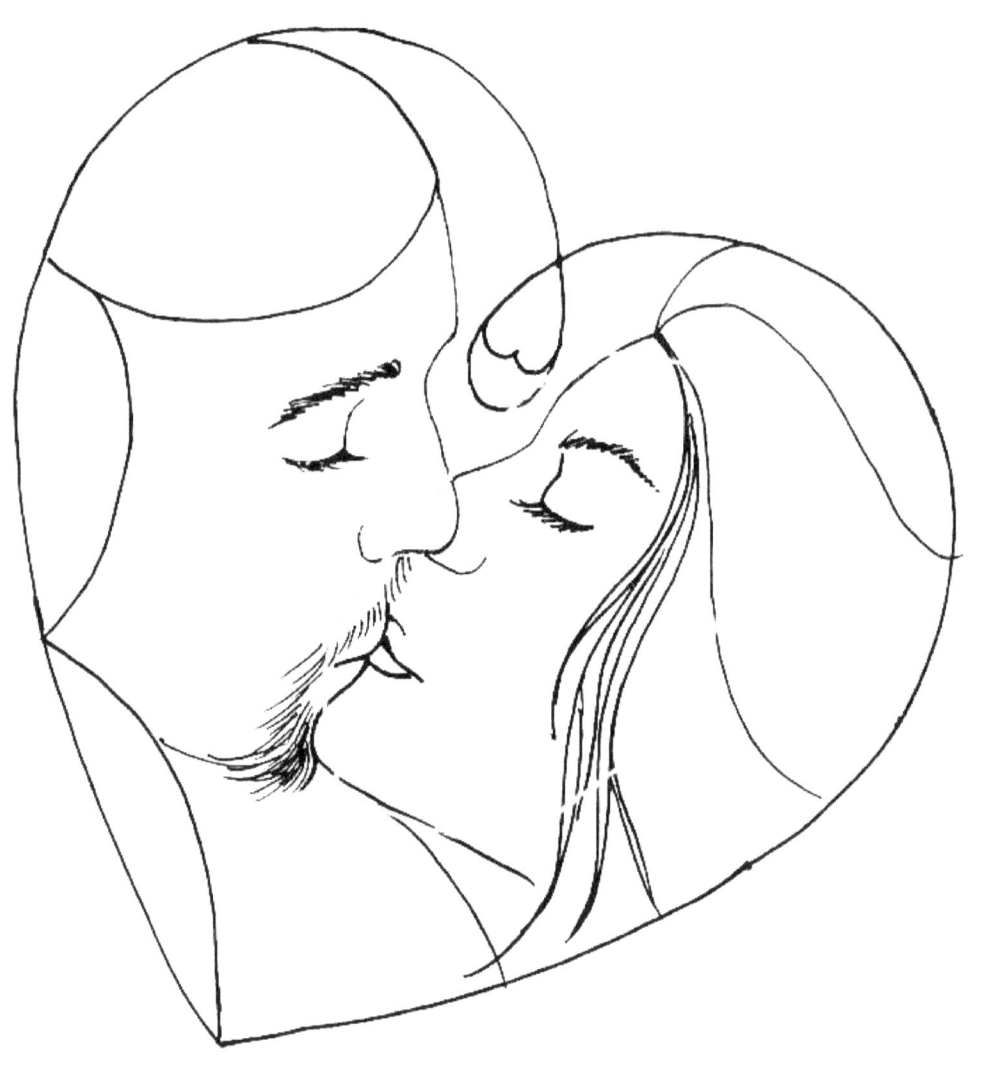

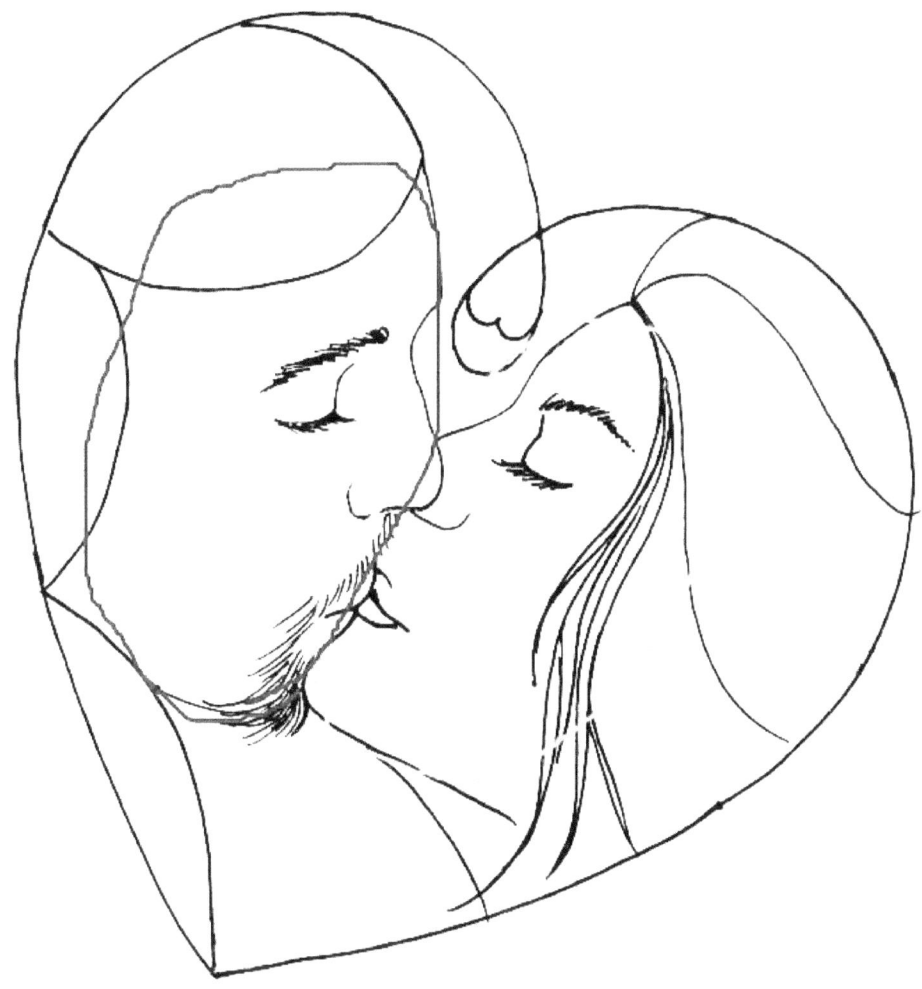

Step 2: You have probably noticed already that these figures are encapsulated inside a heart. We have total confidence that you will be able to draw the entire heart in one swept line, instead of finishing the drawing in a point. Try to make the lines continue in their opposite sides, creating a drop shape, and after that make it again parallel to the first one. Draw small lines creating triangles between these two lines, one right after the other.

For the drop figure make a heart inside of it, with bigger ones created from there- that is being circumscribed to it.

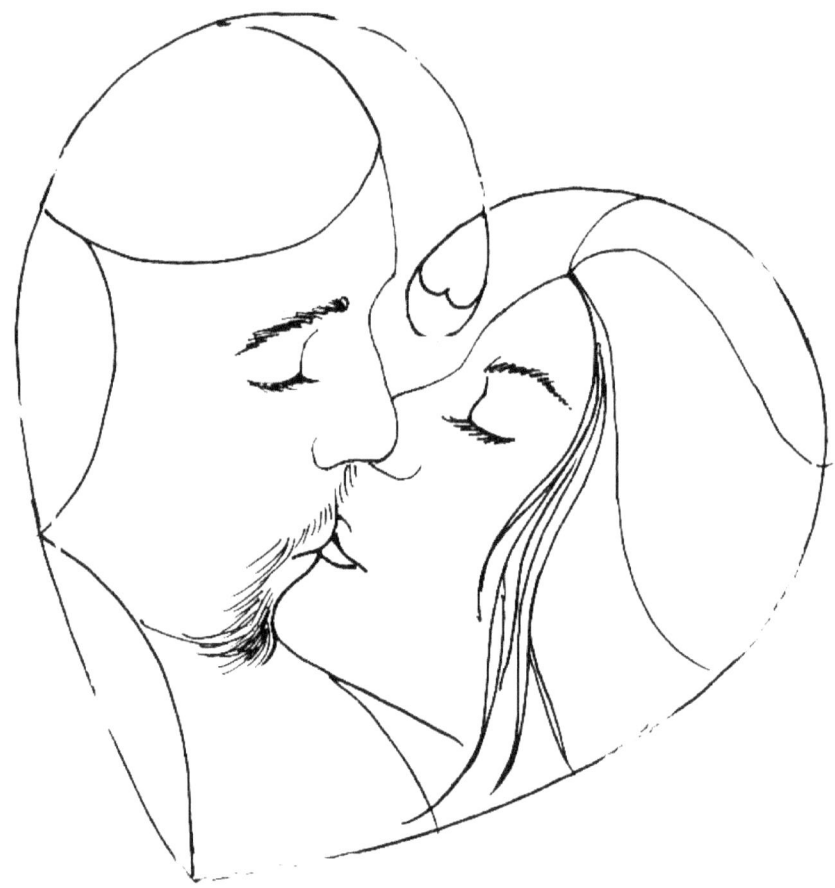

Step 3: Ink all you have make until now and start to get rid of the guiding lines. Use the marker to bulge the heart inside the drop; as it is been told to you earlier, the marker can be used to highlight certain parts of the drawing, so you can use it as you wish.

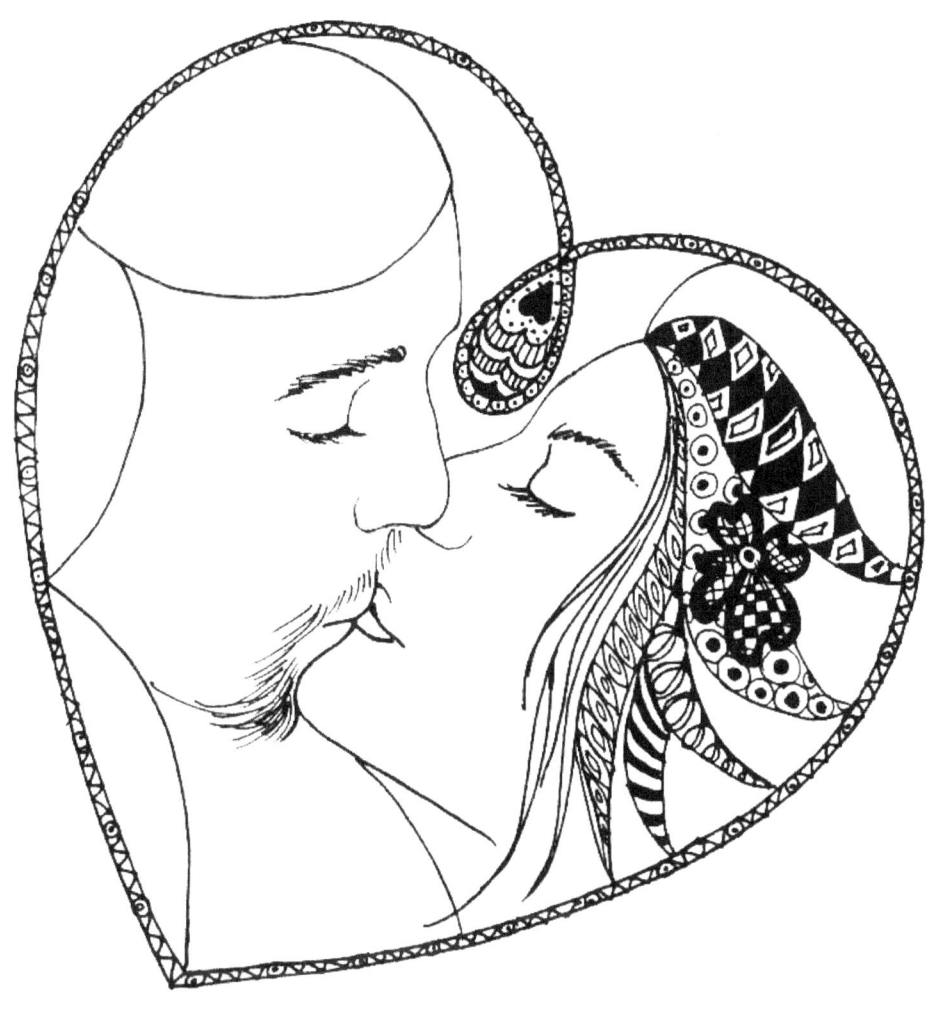

Step 4: In the following next steps we will be working with the girl's cap. For this exercise we will request for you to use as an aid the already sketched lines three steps back, do start another line interjecting with the former one, create a waved line that will reencounter the first one, with this the result is that you will end with figure shaped like a leaf; repeat this action with another leaf like figure. After, create two triangles like contours. Subsequently, make a small circle inside the second *leaf*, from that sketch circumcised heart like figures-with just four will suffice-.

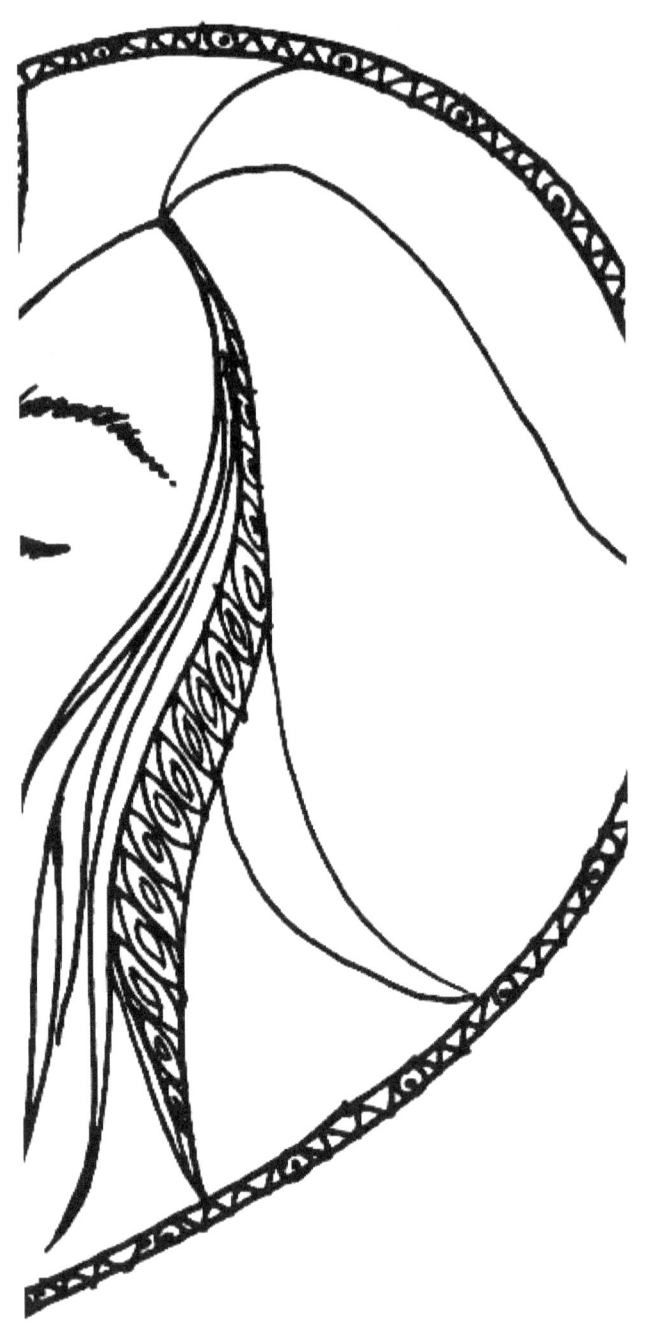

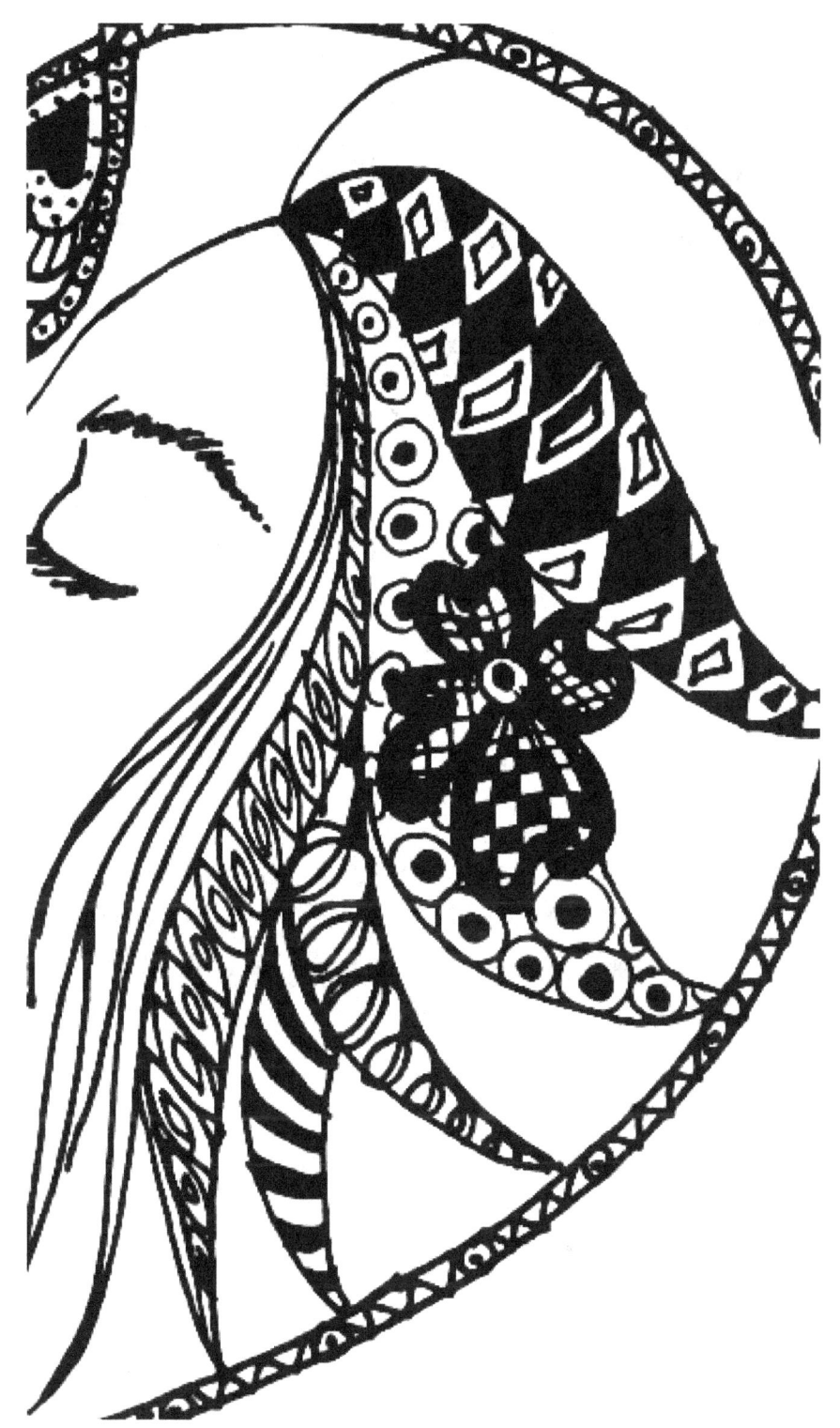

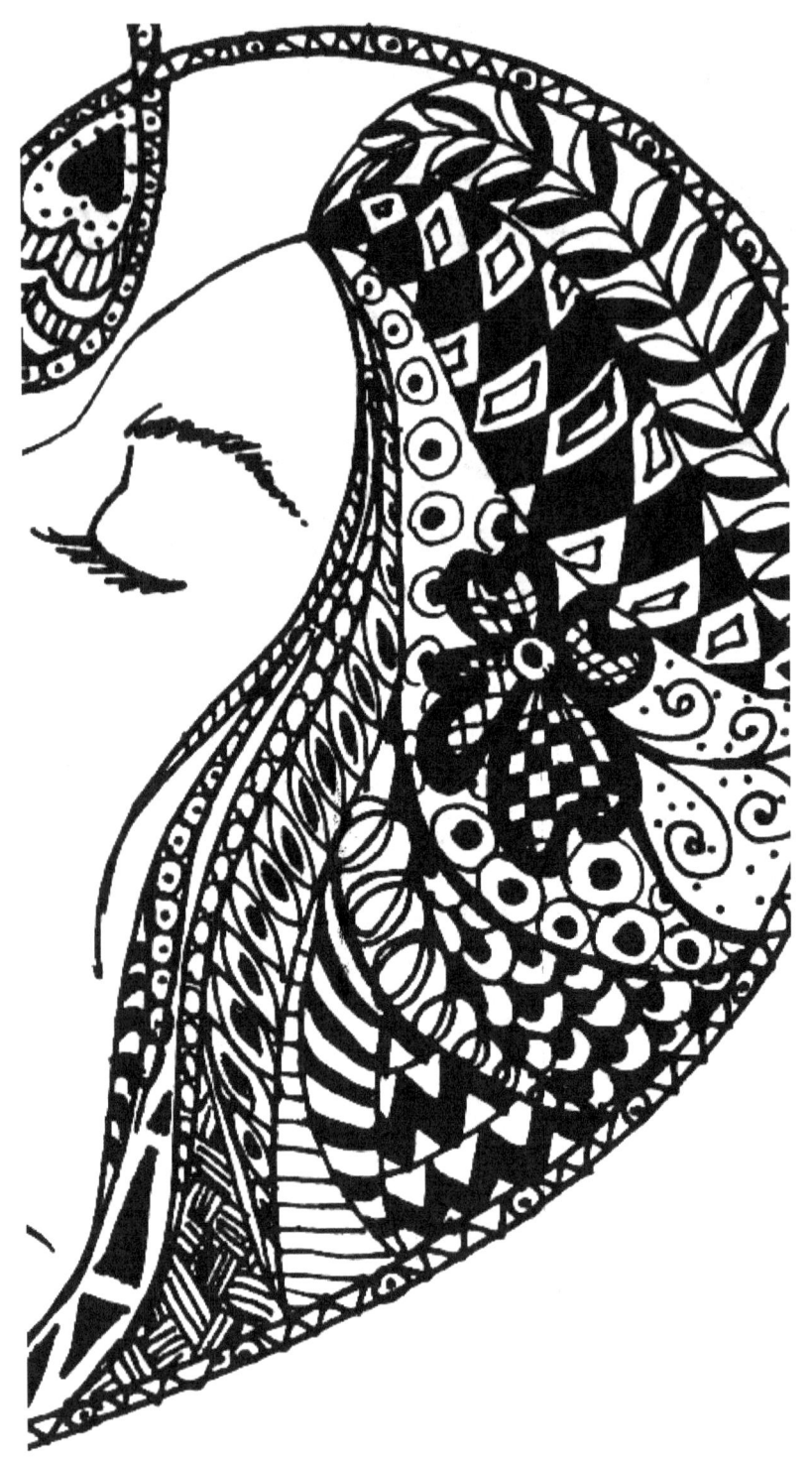

Step 5: Now it is time to start using the ball pen yet again. As you can see in the picture above, the flower is on the leaves, so it will be advice to highlight it with the marker, making the outlines thicker with it. The broad marker can be used to fill parts of these new sketched forms; you could either fill some parts leaving the blanks, or you could draw the shapes that are displayed on the image above (such as: the cheered motive for the flower petals, diamonds for the first leaf, various circles in the second one, arcs encountering them, and horizontal streaks interleaving plain sections with others ink permeated).

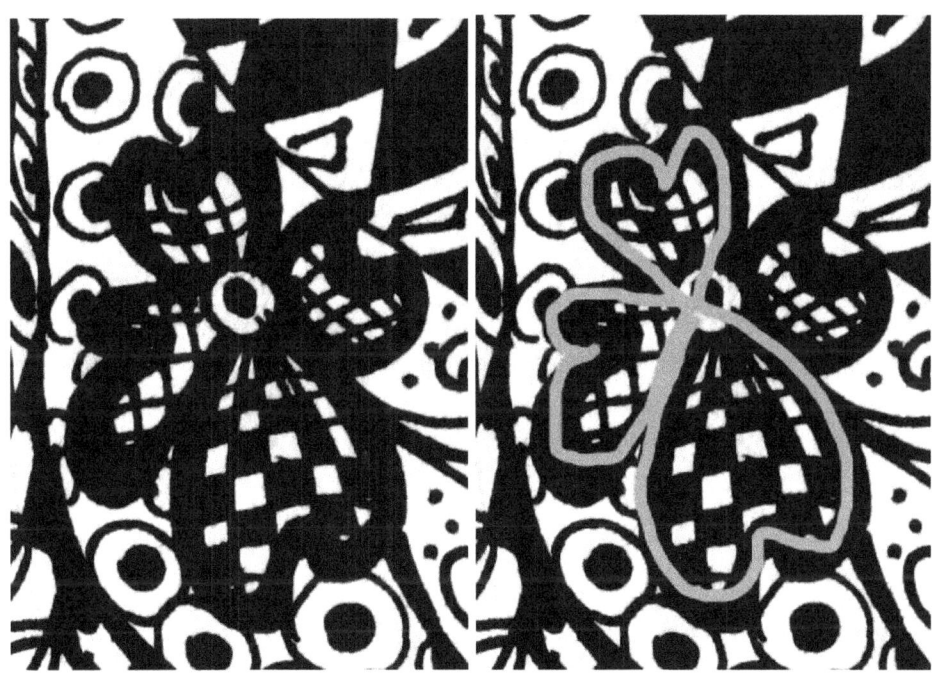

Step 6: You will notice how a nature theme is present in this artwork, differentiating it from the others that we have seen up till now- in those the motive was more animalistic, if even in a majestic way-.

Heretofore we have the leaf shaped figures and the flower, adding to it vertical rows of small leafs will have to be make. Swirling curls will sprout from the flower, use endemic motives to complete the spaces that are still empty; arcs can be also used for something that will appear to be scabs; another motive that can be seen is simple geometrical figures.

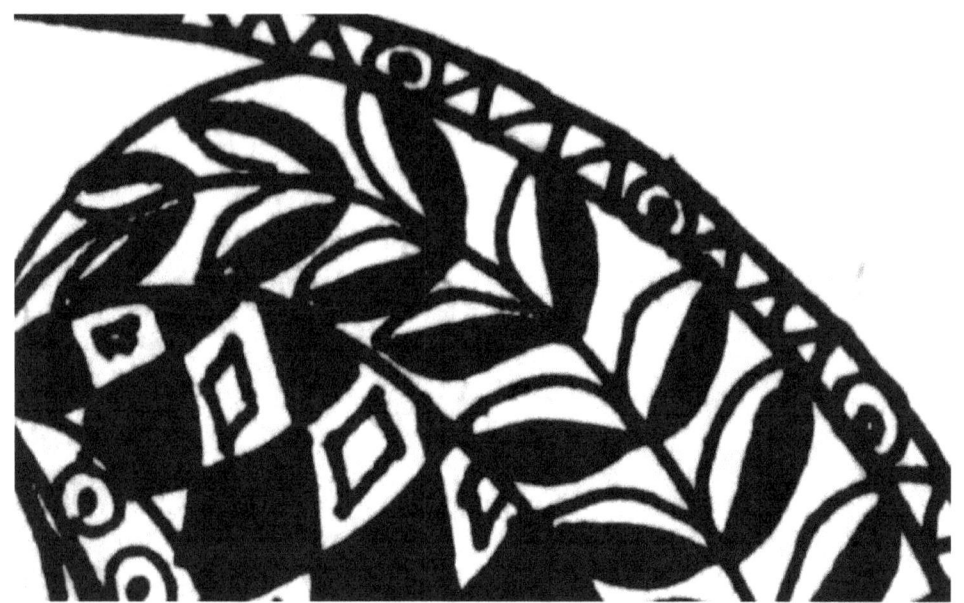

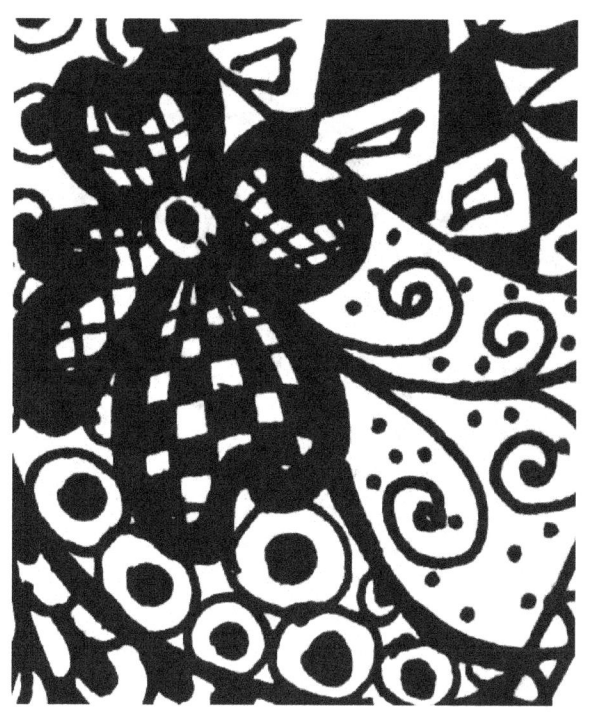

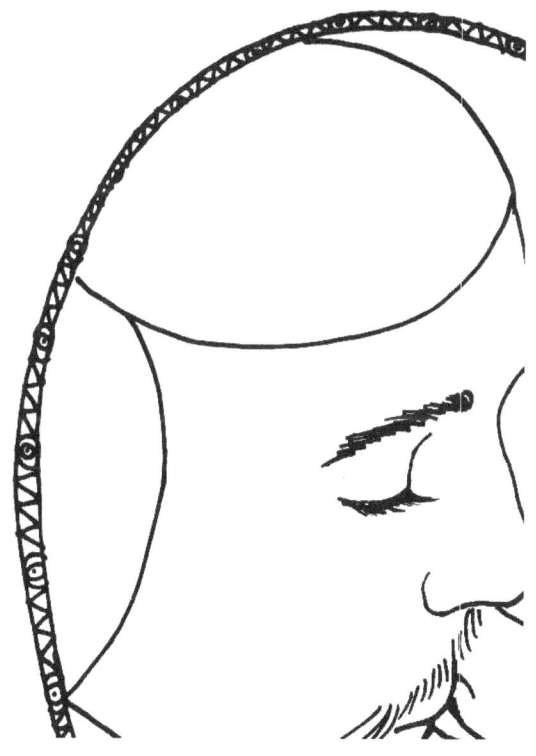

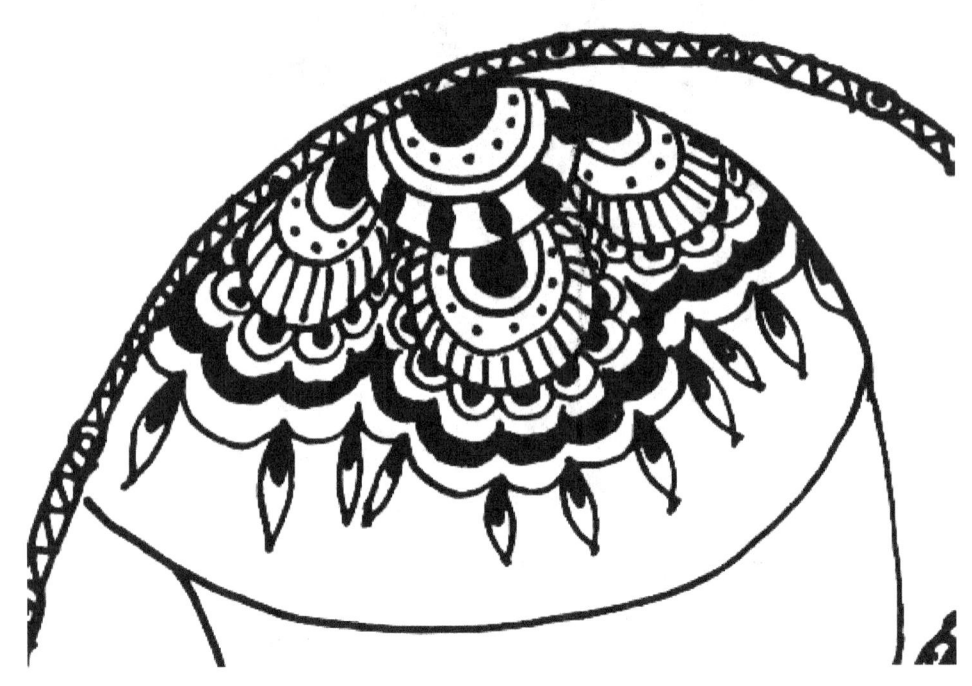

Step 7: We are moving to the man's cap. If you are paying attention you will notice how the motives there resemblance a rose window; the shapes used to attain this are various arcs, all of them coming of one principal semi circled one, more exactly make three big ones and following that, use really petite curvations in succession of each other to create framework for the three bigger pieces. On the joints of this rows, draw leaf like figures. All this can be seen right on the picture on top of this paragraph.

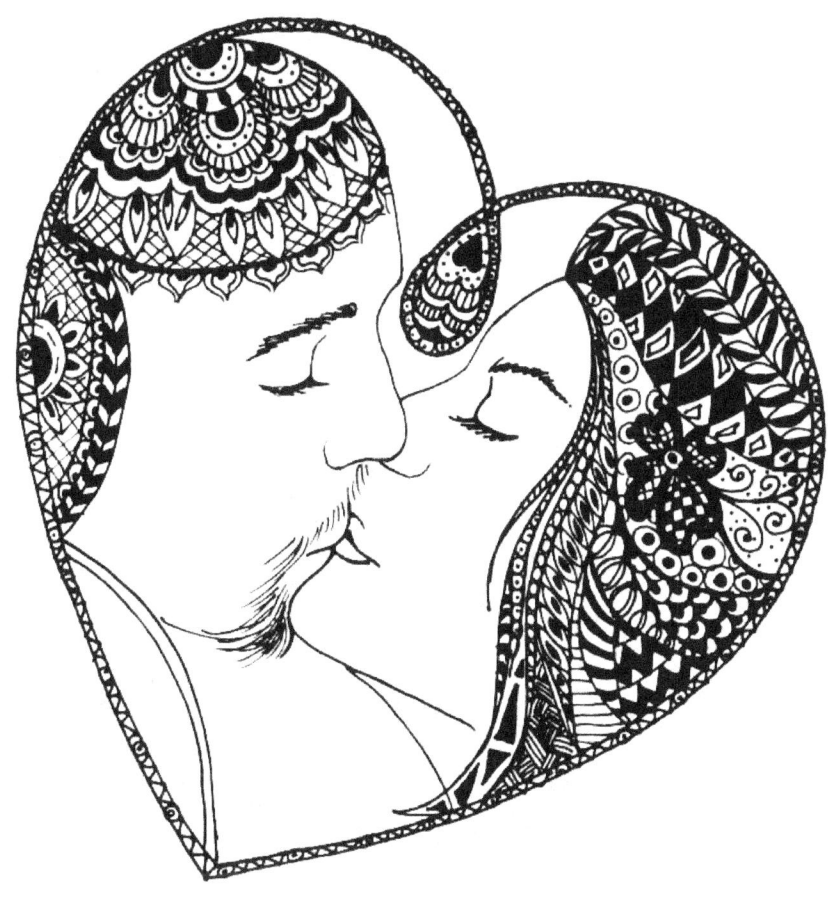

Step 8: Taking the leaf shapes draw others equally fashioned, but huger on size to encapsulate them; draw a net to stick out the former shape, and use a marker to draw a thick arched line below them; right after that you will notice figures that look like some upside down domes- that or really minuscule onions-.

Next we will be focusing on the arc that covers the part where the ear would be located; here the natural motive is again present with a semi-circle surrounded by leafy shapes that bring to mind a sunflower. As it was done prior to this a web is used again to stand out this figure.

Furthering the point about the naturalistic motive a vertical and arched row of leaf closes this second semi-circle. A parallel line is used to accompany the third curvature.

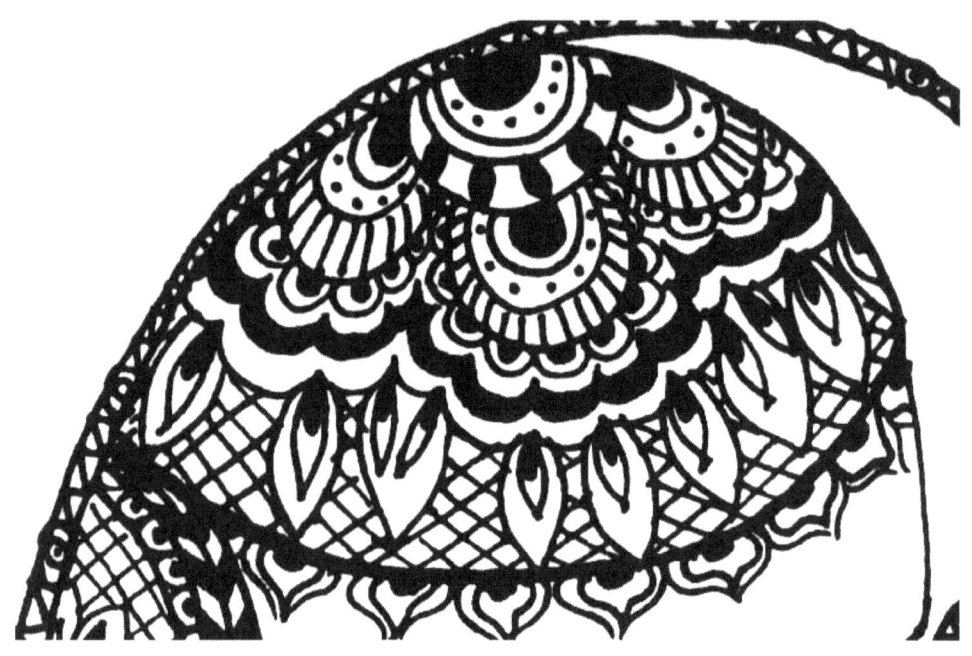

Step 9: Here we go on the inking process again. Use the black to stand out, or to differentiate part, the contrast is quite useful for the onlooker.

Step 10: In this empty arch we will be going back to the geometrical motives to fill the blanks. Like triangles, circles, and pentagons as it is shown above.

Step 11: The next thing to do will be to draw a heart shape figure, with parallel figures of the same contour. Make the first one with a thicker line, you could use the marker for that, and inside of this heart sketch small arcs that will give the sensation of waves on a pond.

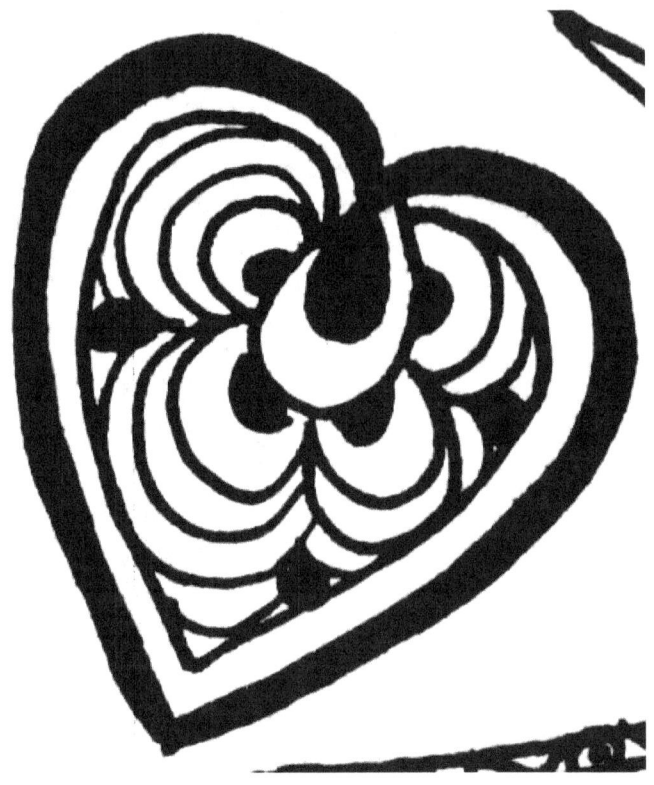

Step 12: Lastly the use of straight parallel lines as background, results in an easy way of separating the main characters from the back drop.

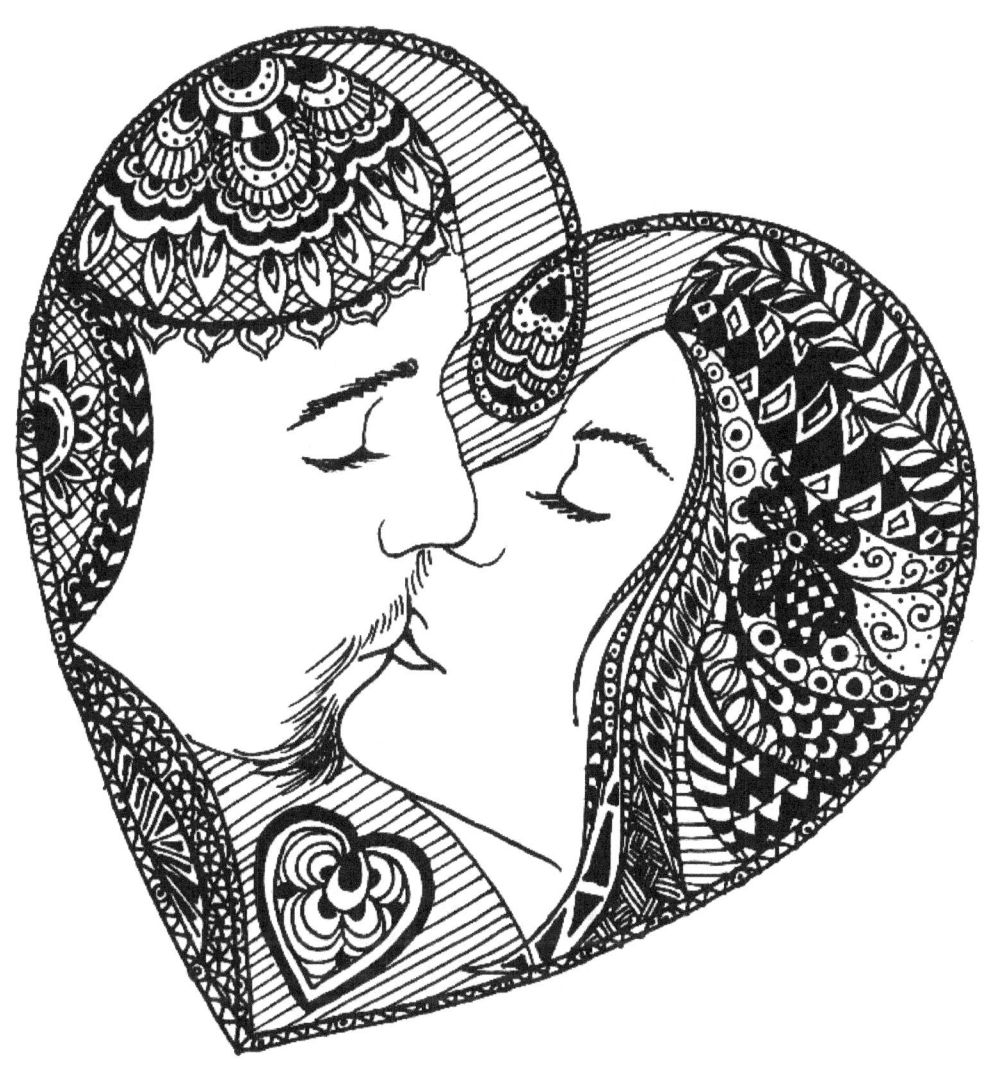

Lesson Five: Her hat suits her well

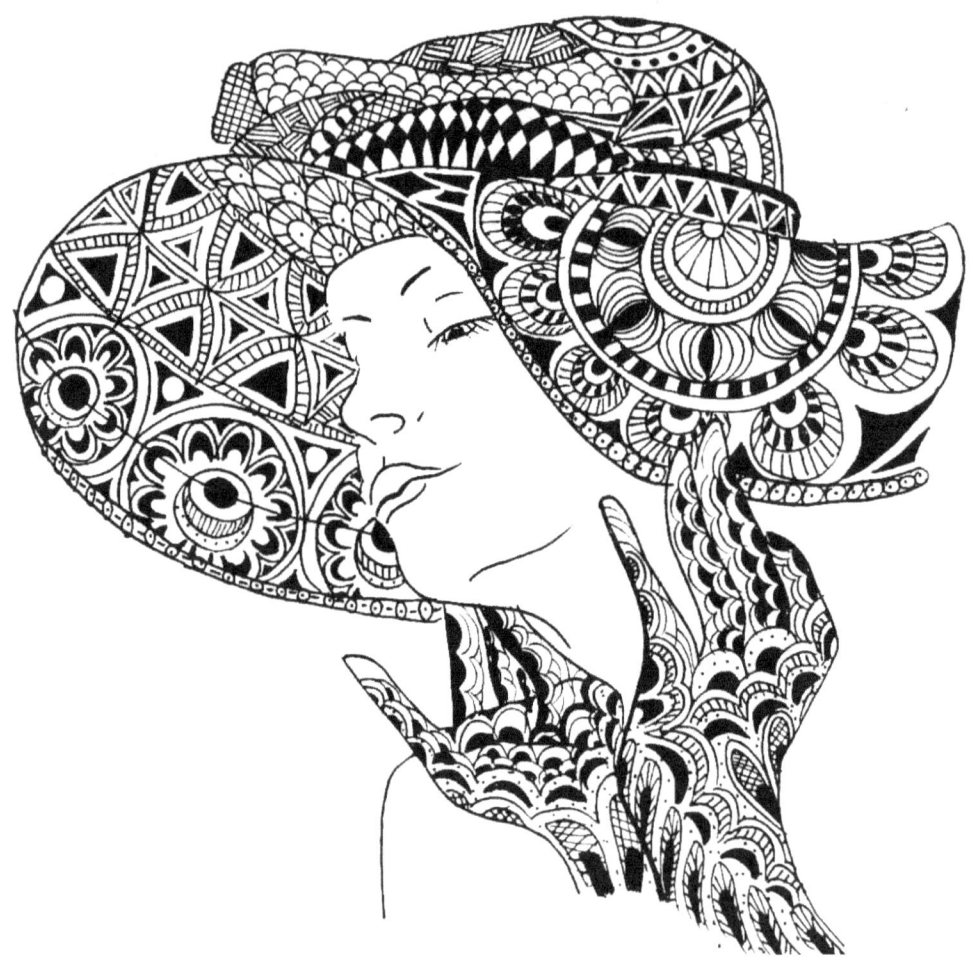

Step 1: We believe that after going on and on about how you should pay attention to the figure and how you can achieve complicated shapes through the use of really simplistic figure, now we could avoid making that suggestion again. Observe this picture, it does look deceptively abstruse, but as all the artworks we seen so far are really quite simple. So this is your first step: relax you are heading for the end of this book manual.

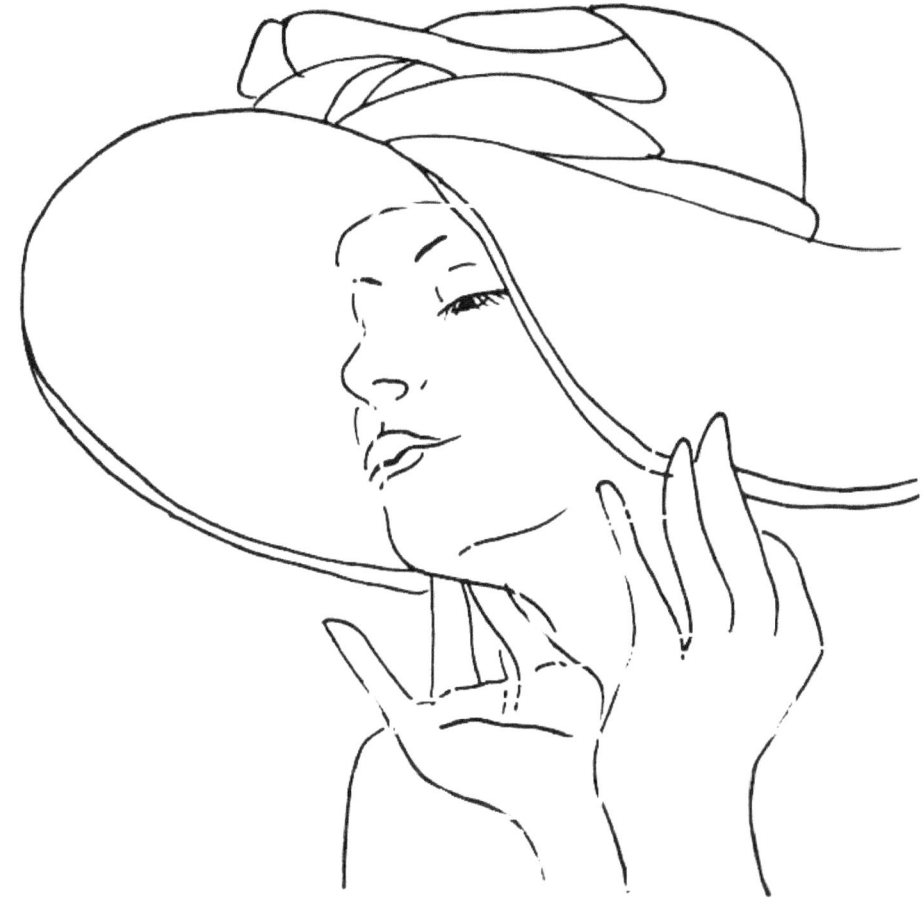

Step 2: Because we know that by now you surely have mastered using the pen and markers, we will ask of you to put your pencil and eraser aside and concentrate on working with ink from the start; along with this command comes another: do not sketch, try to do long lines in one fair swept like it is shown on the figure below.

These pictures have certain forties, add quality to it, and yet again retain the stylistic type of the twenties. Note how the idea of not worrying about making mistakes is clearly shown in the artwork, as some lines are clearly clashing with others.

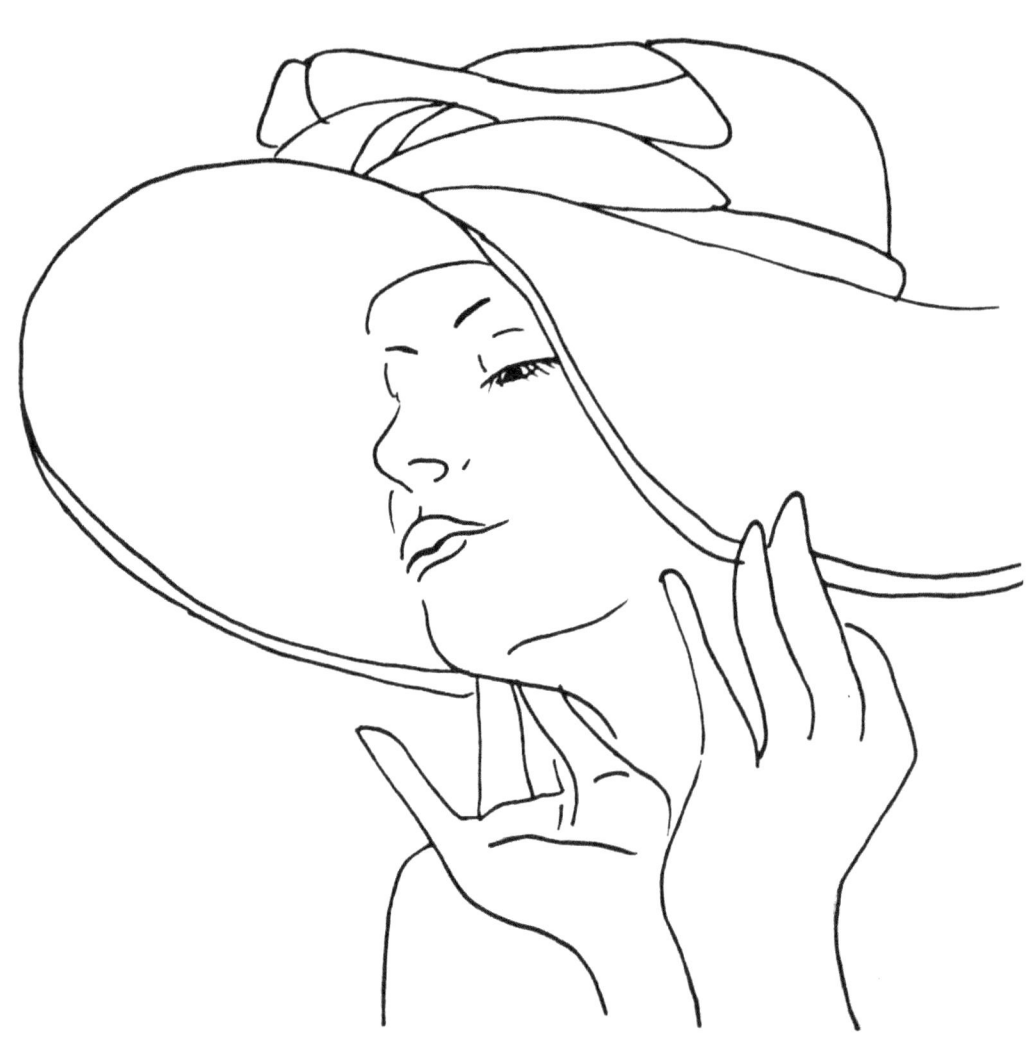

Step 3: Following the image below you will locate yourself on the cap, do a paper wallies made up of triangles, some up and others down. On the lower part of the hat draw circumscribe circles one inside the other, give some space between each of them. Create straight lines coming from the center of the first one; between the lines that are the nearest use vertical lines, one having them closer than the others. The arches that are more distant to each other, can serve to draw what will look like onion pleats, on a row. The use of domed figures can serve to complete the blank spaces; the arcs can go one after the other, the final result will be to have the appearance of a big flower. The marking pen can be used to replete some voided places on the drawings.

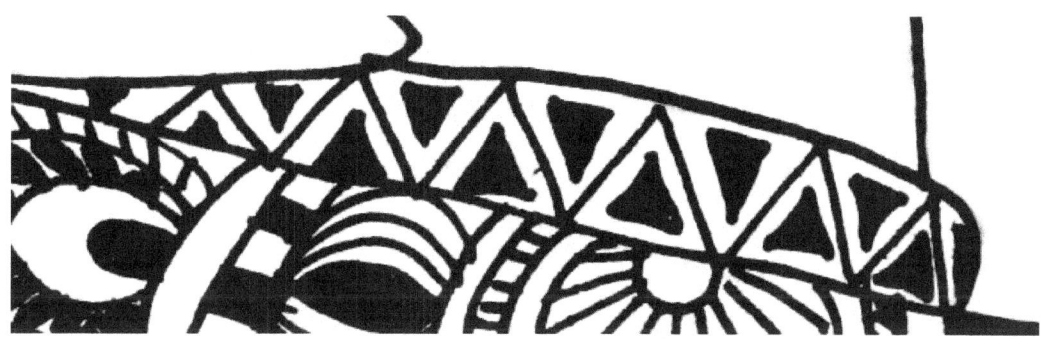

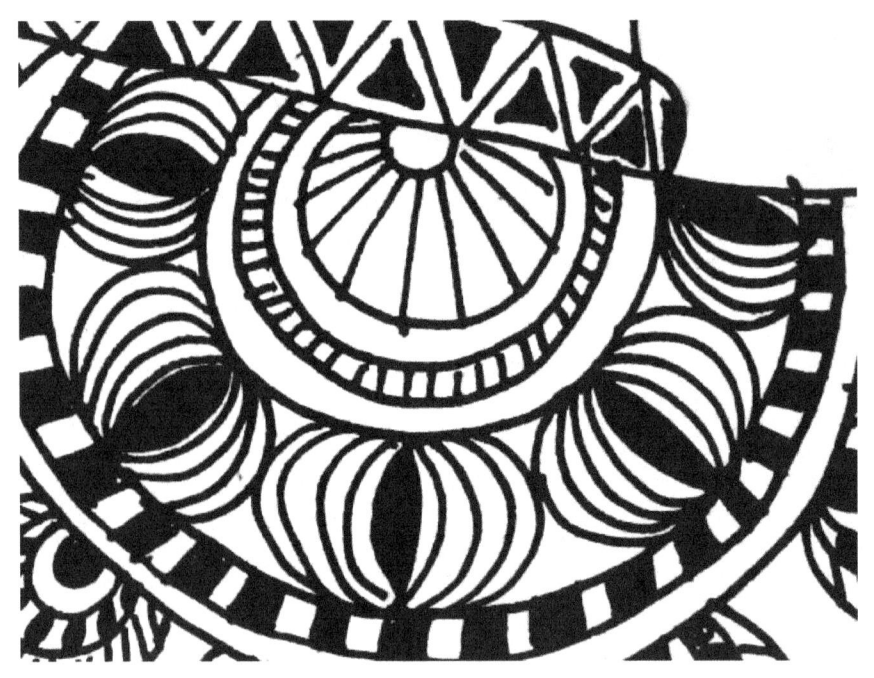

Step 4: Create parallel lines to those outlining the lower part of the hat, and draw garters of circles inside of them.

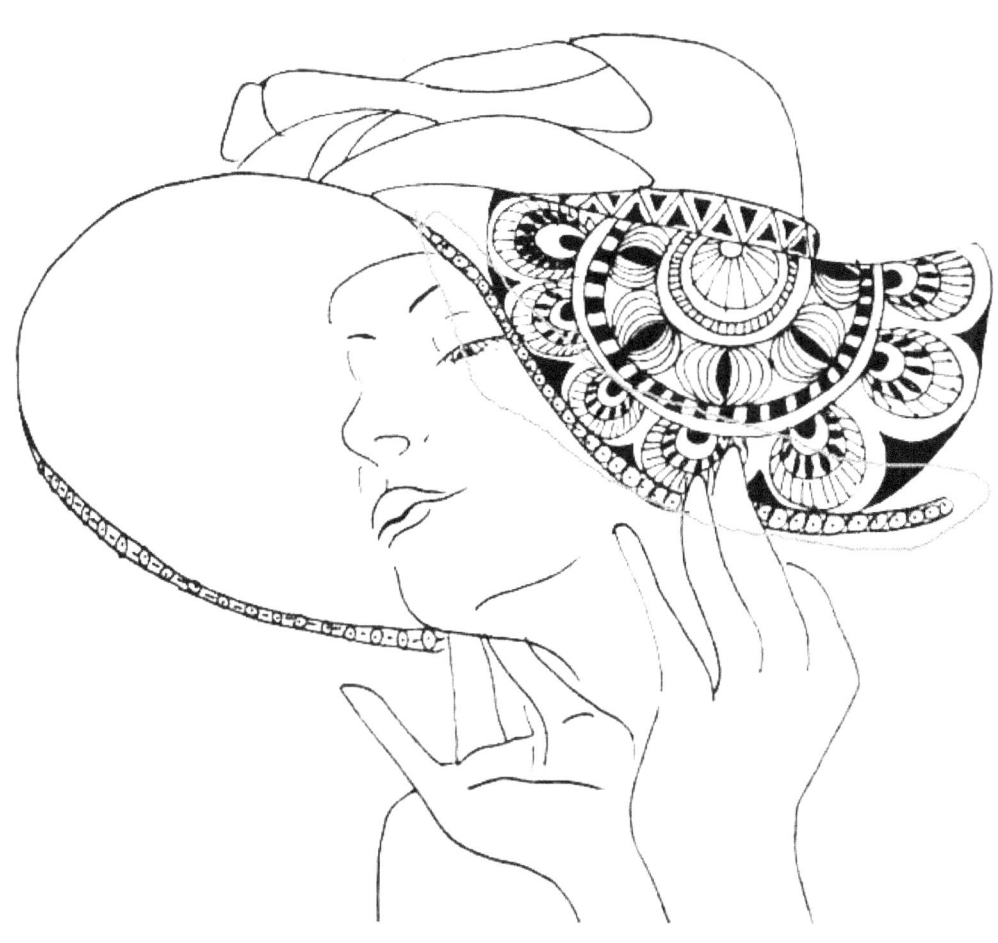

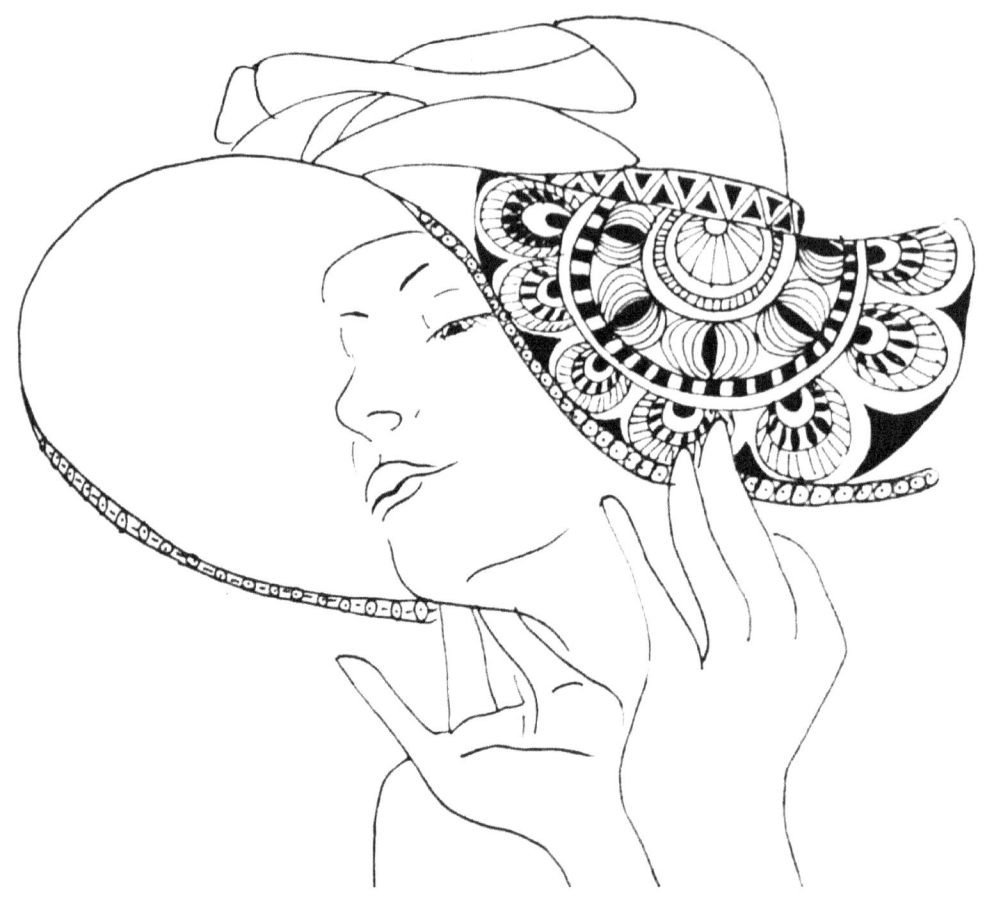

Step 5: We will be jumping to the inward part of the hairwear; taking the line from the lower part start using its shape for sketching equidistant lines, that will be apart from each other.

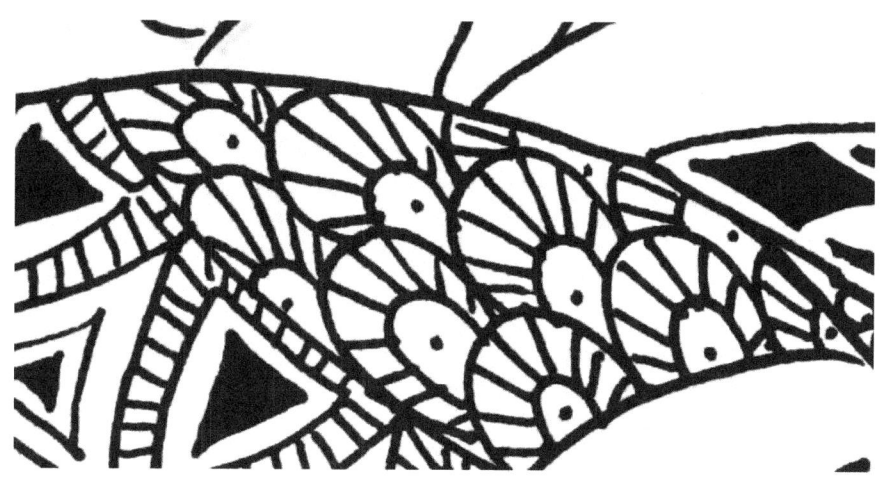

Step 6: Inside them you can start drawing triangles that can be flipped over one row in difference of the other, encountering on the vertex.

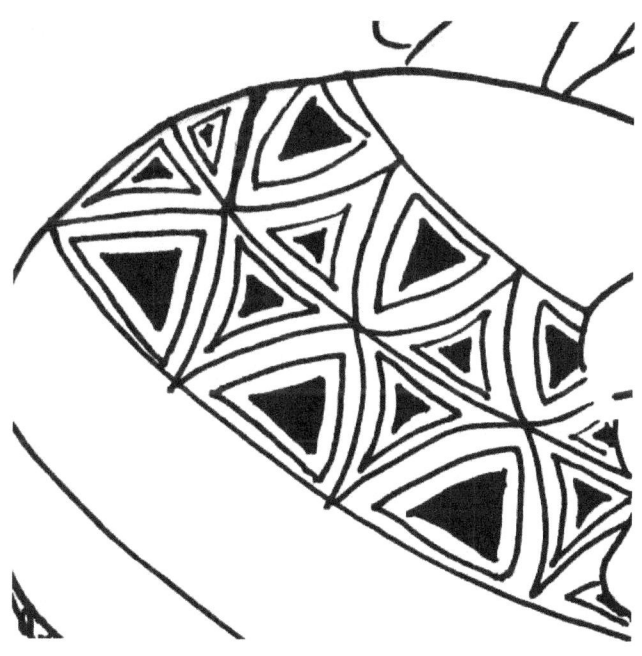

Step 7: Down the rows of triangles create small circles; then do big ones that will have figurines looking like flowers inside-this made of arches, with a circle inside with a smaller one accompanied with a crescent moon within-. As seen below.

Step 8: Still on the inward part of the hat and coming from a top of the forehead of the lady you can make arches to fill that part. With that done, continue by concentrating on the upper part of the cap, there you can use different patterns, such as rhombus, triangles, nets, arches, vertical, and horizontal lines. Using broad tip markers you can delineate and separate parts, also to fill the blanks. Shapes completely painted black contrasting with white ones can serve to create a vibrant image.

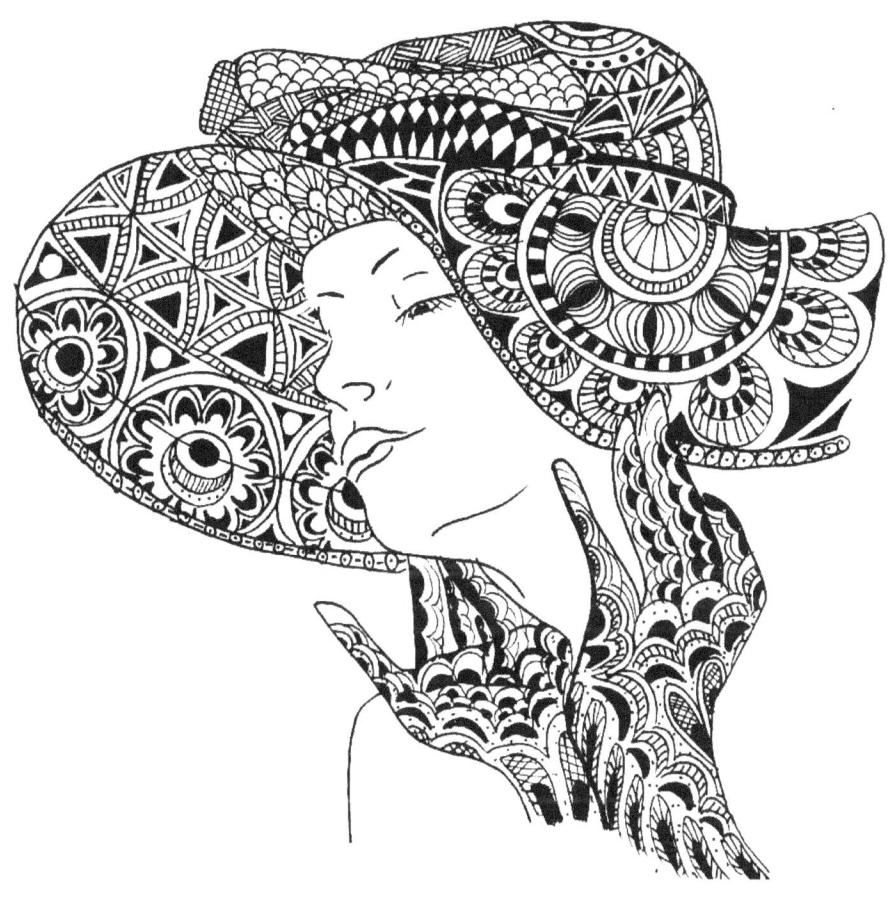

Step 9: As you can see we are leaving the head, neck and shoulders unfilled. The efforts will be boiled down to the gloves. The impression presents on them will be: small arches that will form flakes, and leaf looking figures, together they give a peacock plumage motive to the mitts. Using grids, with pens and markers as tools, to fill some of the vain parts some visual effects can be created.

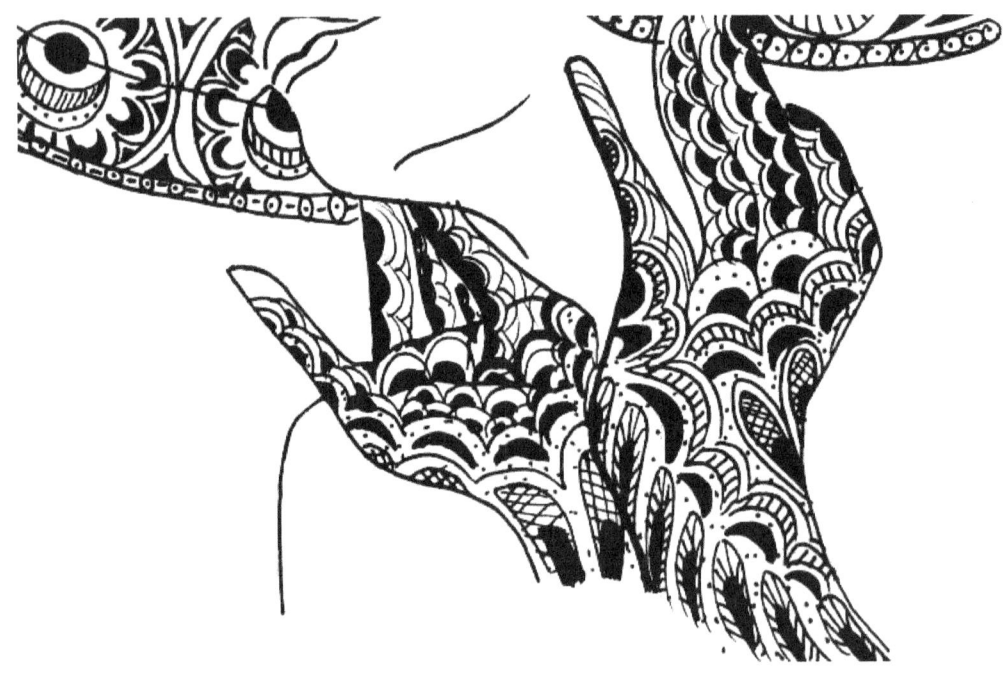

Conclusion

Well, we are here already; five lessons have already passed by. You have had time to practice and practice; now you surely are making ZEN Doodling like nobody's business. But seriously, it is the hope of this manual, that you have grasp the basics of this form of art, so you can go on making your own creations. Perhaps with so many indications you think of this as chore by now, that is not the case by any means, this is supposed to be a tranquilizing activity, not a tedious one; yet it is easy to understand if having to follow so many steps may create an opposite effect.

Please do remember that here we are also attempting to teach you something. If you have been paying attention and following the training until now you will have learnt not only how to create ZEN Doodle, which it will be insisted, are overly complicated doodles, but also stylized figures inspired on Art Deco. By this time you will have notice the most common motives are nature and geometrical figures; also that the use of repeated forms is a part of the course. Go, get a sheet of paper and start drawing. Have some fun!

Thank you!

Thank you for choosing our book, we hope you found it interesting and helpful.

If you liked the book, please give us a favor to write your review.

We would really appreciate this!

If you would like to have a bonus – **FREE BOOK**, please send the screenshot of your review to this e-mail: **kelly.artbooks@gmail.com** and we will send you a **FREE BOOK** in PDF as a **GIFT!****

Hope to see you in our future books and good luck in your drawing experience!

**** in the e-mail subject please mention the name of the book you reviewed and the author.**

Other Books from Jane McKenty

ZEN DOODLE: The Art of Zen Doodle. Drawing Guide with Step by Step Instructions. Book one.

ZEN Doodle: The Art of Zen Drawing. Master Zen Doodle with Step by Step Instructions. Book two.

ZEN CATS: Drawing Amazing Zen Doodle Cats

ZEN Horses: Drawing Amazing Zen Doodle Horses!

ZEN DOGS: Drawing Zen Doodle Dogs

ZEN Doodle Art: Drawing Underwater Life with Amazing Zen Doodle Technique